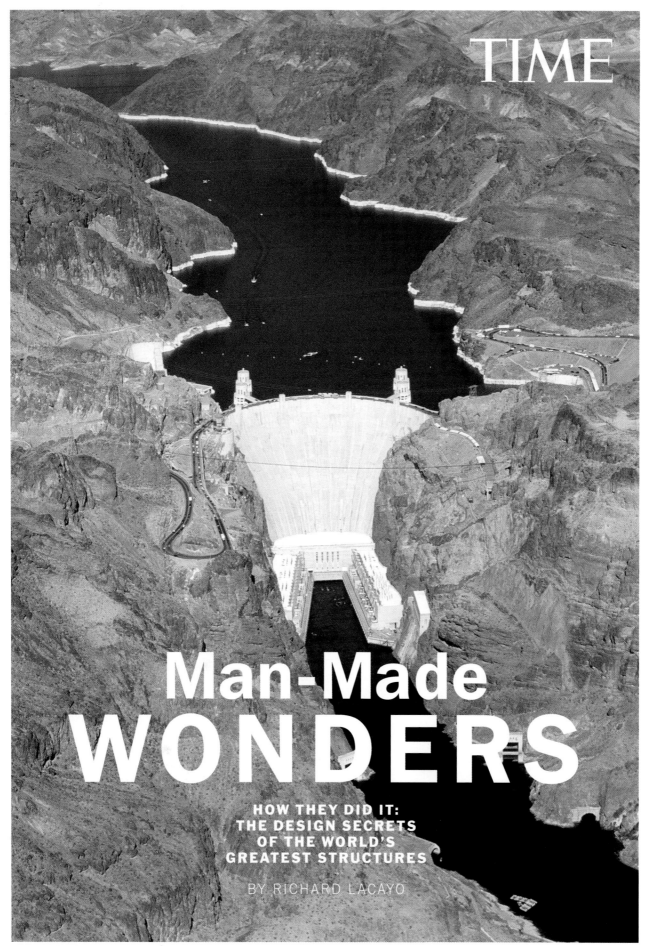

TIME

Man-Made
WONDERS

HOW THEY DID IT: THE DESIGN SECRETS OF THE WORLD'S GREATEST STRUCTURES

BY RICHARD LACAYO

HOLDING ACTION The Hoover Dam walls up the waters of the Colorado River.

TIME

MANAGING EDITOR Richard Stengel
DESIGN DIRECTOR D.W. Pine
DIRECTOR OF PHOTOGRAPHY Kira Pollack

MAN-MADE WONDERS
WRITER AND EDITOR Richard Lacayo
DESIGNER April Bell
PHOTO EDITOR Patricia Cadley
GRAPHICS EDITOR Lon Tweeten
COPY EDITOR David Olivenbaum
REPORTERS Elizabeth Bland, Molly Martin
EDITORIAL PRODUCTION Lionel P. Vargas

TIME HOME ENTERTAINMENT
PUBLISHER Jim Childs
VICE PRESIDENT, BUSINESS DEVELOPMENT & STRATEGY Steven Sandonato
EXECUTIVE DIRECTOR, MARKETING SERVICES Carol Pittard
EXECUTIVE DIRECTOR, RETAIL & SPECIAL SALES Tom Mifsud
EXECUTIVE PUBLISHING DIRECTOR Joy Butts
DIRECTOR, BOOKAZINE DEVELOPMENT & MARKETING Laura Adam
FINANCE DIRECTOR Glenn Buonocore
ASSOCIATE PUBLISHING DIRECTOR Megan Pearlman
ASSISTANT GENERAL COUNSEL Helen Wan
ASSISTANT DIRECTOR, SPECIAL SALES Ilene Schreider
BOOK PRODUCTION MANAGER Suzanne Janso
DESIGN & PREPRESS MANAGER Anne-Michelle Gallero
BRAND MANAGER Michela Wilde
ASSOCIATE BRAND MANAGER Isata Yansaneh
ASSOCIATE PREPRESS MANAGER Alex Voznesenskiy

EDITORIAL DIRECTOR Stephen Koepp
EDITORIAL OPERATIONS DIRECTOR Michael Q. Bullerdick

SPECIAL THANKS TO: Christine Austin, Katherine Barnet, Jeremy Biloon, Stephanie Braga, Susan Chodakiewicz, Rose Cirrincione, Lauren Hall Clark, Jacqueline Fitzgerald, Christine Font, Jenna Goldberg, Hillary Hirsch, David Kahn, Amy Mangus, Robert Marasco, Kimberly Marshall, Amy Migliaccio, Nina Mistry, Dave Rozzelle, Ricardo Santiago, Adriana Tierno, Vanessa Wu, TIME Imaging

ISBN 10: 1-61893-018-4
ISBN 13: 978-1-61893-018-7
Library of Congress Control Number: 2012941213

We welcome your comments and suggestions about TIME Books. Please write to us at
TIME Books, Attention: Book Editors, P.O. Box 11016, Des Moines, IA 50336-1016.
If you would like to order any of our hardcover Collector's Edition books, please call us at
1-800-327-6388, Monday through Friday, 7 a.m. to 8 p.m., or Saturday, 7 a.m. to 6 p.m., Central Time.

HEIGHT AND LIGHT
The 12th-century basilica of
Saint-Denis, near Paris, was the
first church to be remodeled
in the Gothic style.

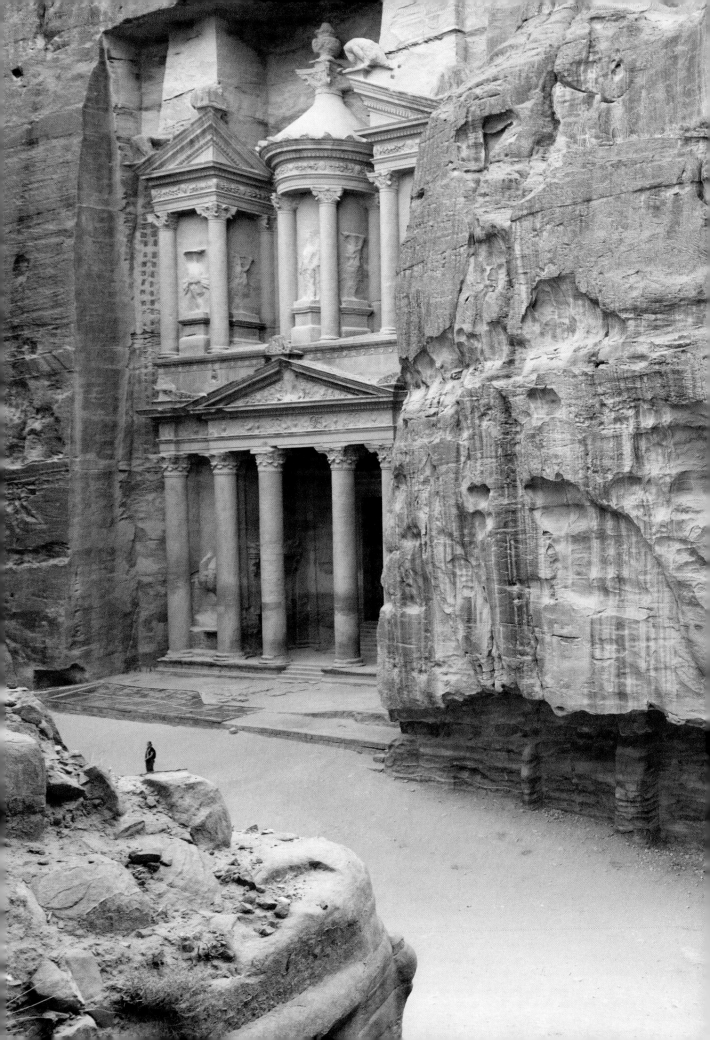

CONTENTS

SET IN STONE
The so-called Treasury at Petra, in Jordan, is carved from solid rock.

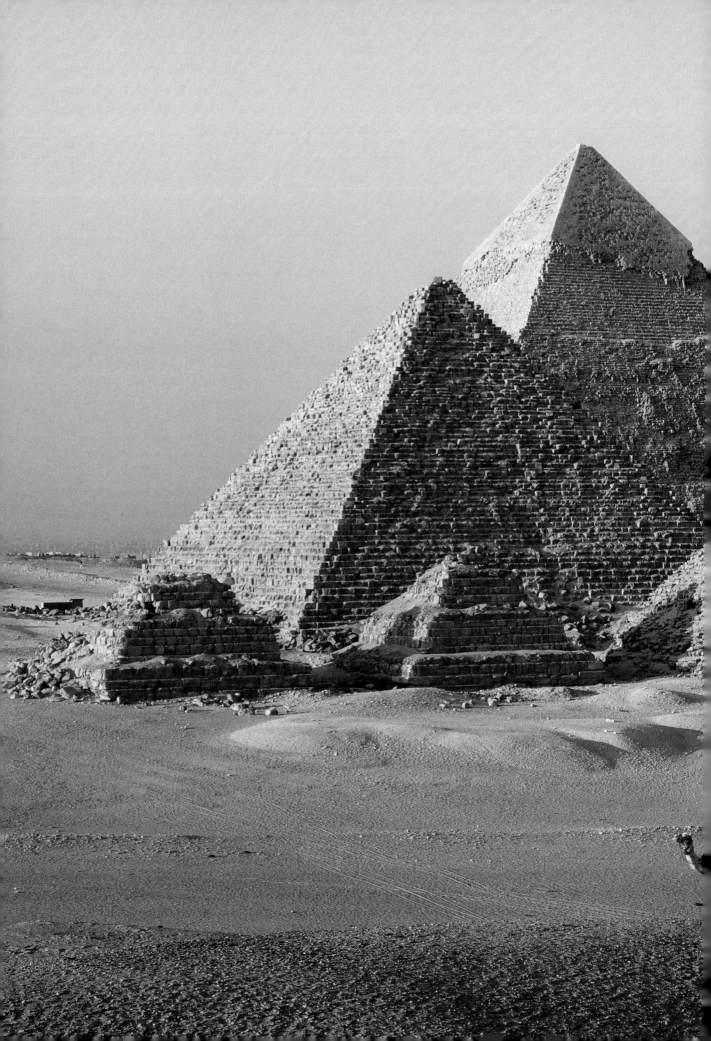

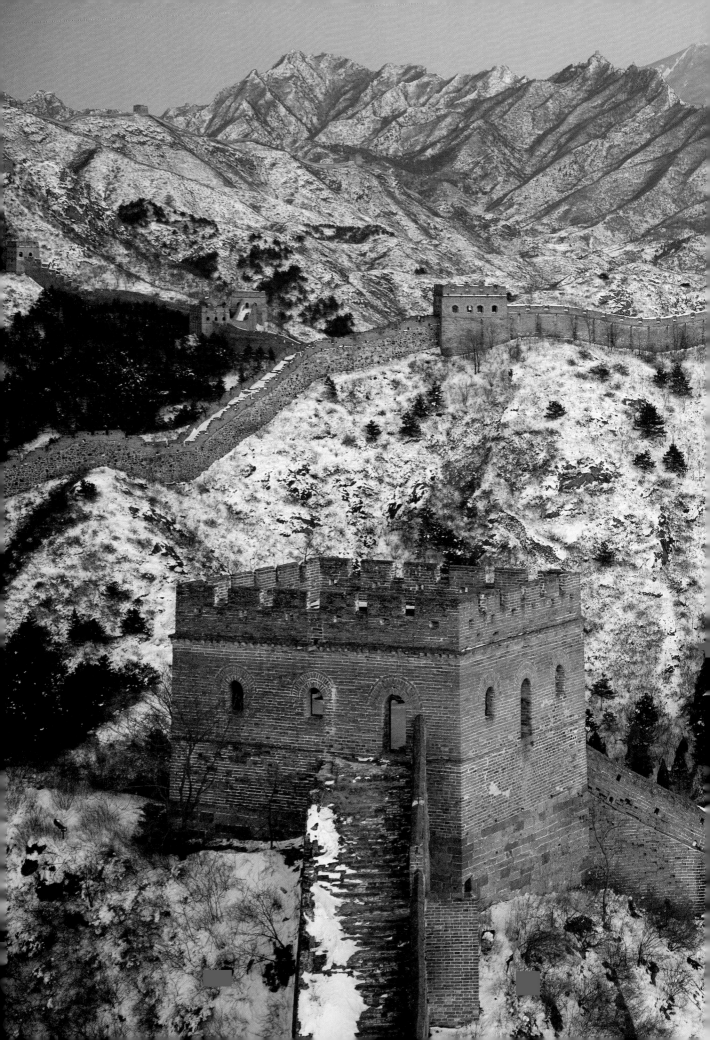

NO TRESPASSING
The Jinshanling section of
China's Great Wall, built
to deter invaders, courses
through mountains
northwest of Beijing.

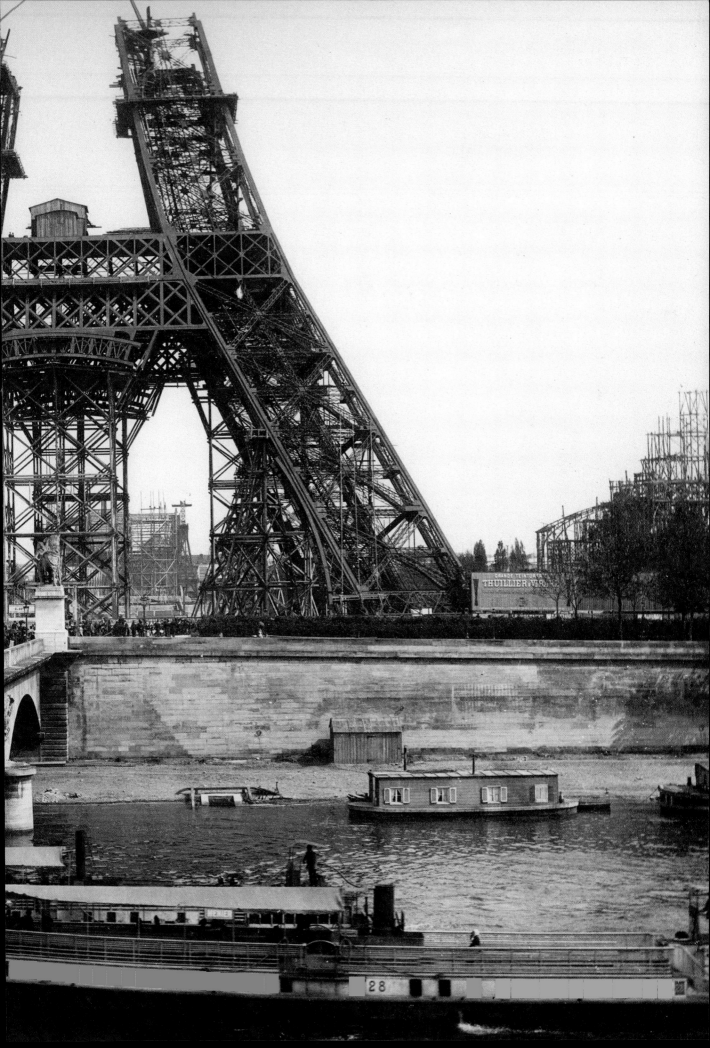

THE HIGH ROAD
With its deck a
vertiginous 900 feet
above the ground, the
Millau Viaduct crosses
the valley of the river
Tarn in southern France.

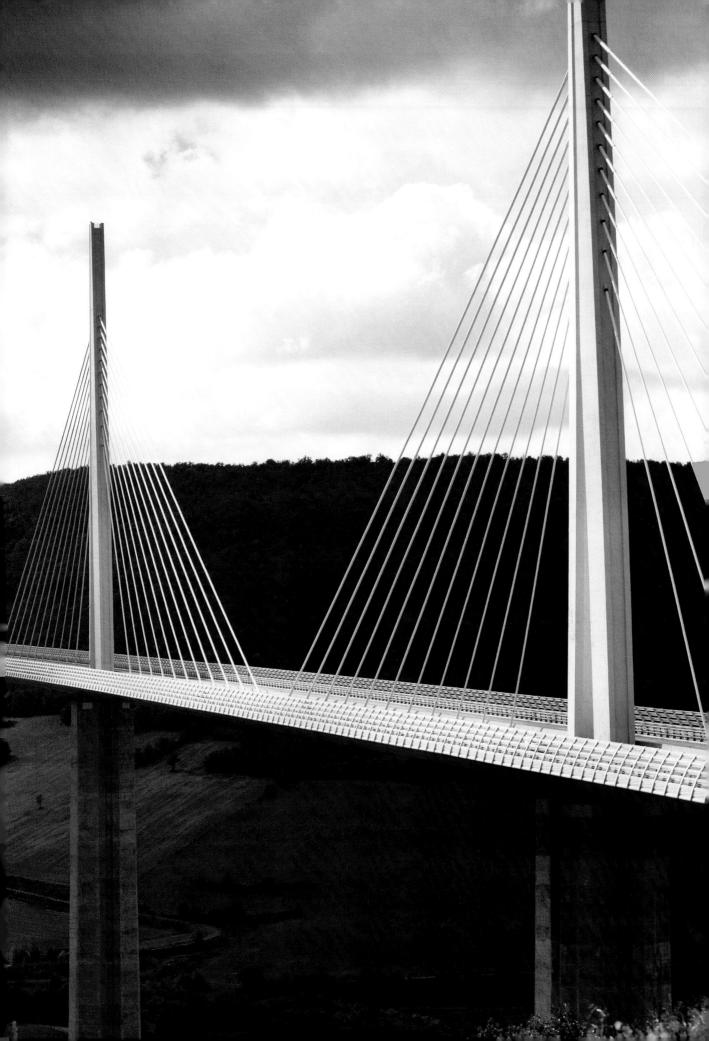

FOREWORD
BY RICHARD LACAYO

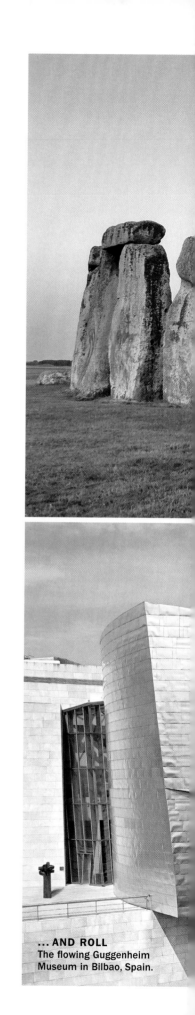

IN THE FIRST CENTURY B.C., THE Roman architect and engineer Vitruvius produced a famous treatise, *De Architectura,* in which he laid out a succinct formula for the virtues that every good building should possess. *Firmitas, utilitas, venustas* were his trio of essentials—strength, function, and delight or beauty. Strength meant a building should stand firm. Function meant it should serve the purpose for which it was built. As for delight, that needs no explanation. A good building, whether it's a church or a post office, should give pleasure to the eye and spirit.

More than 2,000 years later, the Vitruvian triad still sounds right. Interestingly, the man put strength in first place. Before anything else, before we can use them or enjoy them, we need the things we build simply to hold fast. From the time prehistoric people first cobbled together a shelter from sticks or piled one stone on top of another, humans have confronted that problem, with varying degrees of success. And with the passing centuries, as civilizations unfolded around the world and building became one of their paramount pursuits, the things people were willing to attempt became ever more ambitious. Great buildings, as well as the elements of what we now call civil engineering—roads, bridges, aqueducts, dams—were meant to speak of a civilization's power and mastery. They became the essential markers of a great culture, and accordingly they became ever grander in design and scope and ever more

challenging to construct.

So "how?" became one of the essential questions of history. How exactly do you transport the immense megaliths of Stonehenge from the mountains of Wales to the plains of Salisbury, and then somehow prop them up vertically and lay a lintel stone just as large and heavy across them? How do you move fresh water from mountain springs to ancient cities? How do you blast a tunnel through an entire Swiss Alpine range or underneath a river? We all know from the movies that if you build it, they will come. But first you have to figure out how to build it.

These are questions that people have always looked to engineers to answer, even before there was a distinct occupation of that name. As with architecture, not until the 19th century was engineering a profession in the modern sense, one with degrees, licenses, and other credentials. All of that was largely an outgrowth of the Industrial Revolution, the great explosion of building and manufacturing that began in Britain before spreading out across Europe and North America.

Long before then, however, there were men designated to oversee great building projects. The Gothic cathedrals, for instance, were built under the supervision of master stonemasons, often of high rank. They made numerous construction plans and even full-scale drawings of building details, as well as full-scale molds of important sections. Before there was a profession of engineering

... AND ROLL
The flowing Guggenheim Museum in Bilbao, Spain.

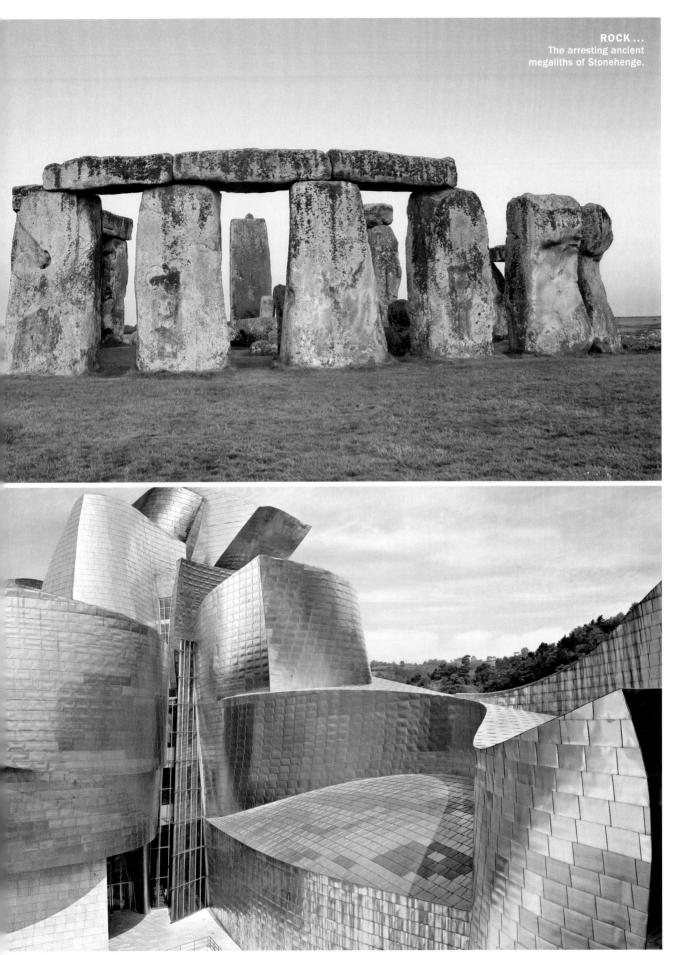

ROCK ...
The arresting ancient
megaliths of Stonehenge.

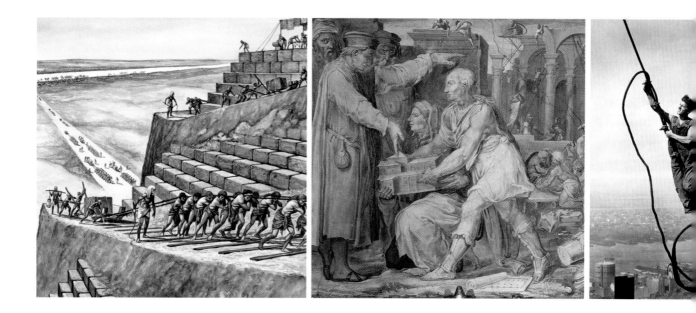

there were also men who regarded themselves as mechanical and civil engineers, though their backgrounds might have been in mathematics, the sciences, or even law. As the man who rediscovered the means for constructing giant domes, the 15th-century Italian artist and architect Filippo Brunelleschi, the designer of Il Duomo in Florence, is rightly regarded as one of the greatest engineers in history. But he was by training a goldsmith.

Most engineering advances depend on either new materials or innovations in structural design or working methods. It was only because the Romans perfected concrete, a mixture of volcanic material like pumice or volcanic ash with quicklime and aggregate, such as sand, gravel, or crushed stone, that they were able to produce the domes and arches that characterized their empire. It was because Gothic builders developed the flying buttress that they could erect immense churches with delicate walls and large windows—so different from the brute mass of their Romanesque predecessors—that were still braced strongly enough to support a heavy roof. And long suspension spans like the Brooklyn Bridge required the prior development of caisson construction, a technique using submerged, airtight wooden compartments to hold the workmen who dug out the bridge's riverbed foundations.

And then there are tools. The ability to use them is one of the fundamental things that make us human. And the evolving size and complexity of construction projects is accompanied by the development of tools of ever greater sophistication and usefulness. One reason we stand in awe of the pyramids is that we know the Egyptians who built them had not yet invented the wheel, which made the task of moving giant building stones infinitely more difficult. We do assume the Egyptians had levers to help them lift and transport their giant obelisks. That essential device was the great force multiplier of the ancient world. The Greek philosopher Archimedes was only exaggerating a bit when he famously said: "Give me a place to stand and with a lever I will move the whole earth."

Later Greek thinkers identified other "simple machines," what we would call tools. Those included the wheel and axle, the pulley, the inclined plane, the wedge, and the screw—simple, true, but effective enough to build the ancient temples and amphitheaters. Men learned to quarry stone by hammering a wooden wedge into a cliffside fissure, soaking it, then letting it expand to crack the block free. Over time they learned much more—how to pump water with siphons, to dig tunnels with giant earth-boring mechanisms, and to assemble trusses in the weightless vacuum of space. Even the humble wheelbarrow, in wide use by the mid-13th century,

made the cathedrals easier to build. And in the late 20th century a new kind of tool emerged: the computer. It was the spread of computer-aided design that made it possible to produce the improbably irregular silhouettes of buildings like Frank Gehry's bellying Guggenheim Museum in Bilbao, Spain, or the spine-tingling trapezoid of the CCTV Headquarters in Beijing.

One great advantage of computer design is that software now permits engineers to model how materials like steel and concrete will respond to stress over time, so they can make accurate predictions of building-component performance. In earlier centuries, a more common way of doing that was by trial and error, sometimes with disastrous results. The history of engineering is literally littered with rubble. Collapse was a bitter price to pay for human miscalculation, but at least it was a learning experience. When part of the nave of Cluny Abbey in France tumbled in 1125, it taught medieval builders that the elegant thin stone walls they favored were not strong enough by themselves to support heavy vaulting. That pointed the builders to the idea of the exterior flying buttress. The spectacular swaying collapse of the Tacoma Narrows Bridge in a windstorm in 1940 compelled a generation of civil engineers to reconsider how much deck bracing a bridge required.

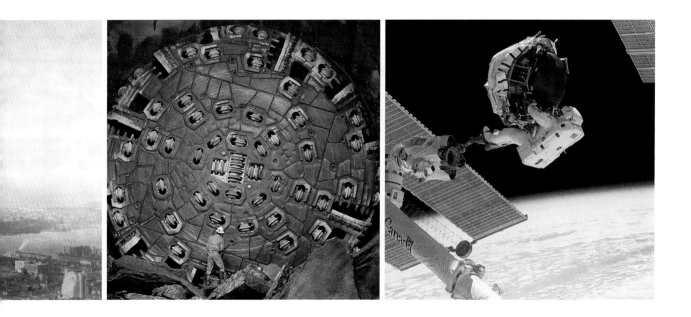

Elegant engineering solutions can have their own kind of beauty. Who doesn't love to look at the Roman aqueducts, or the cathedral at Chartres, or the Golden Gate Bridge? But the most beautiful structures aren't necessarily the most impressive from an engineering standpoint. The Taj Mahal would rank high on any list of the architectural sublime, but it didn't actually represent much of a building challenge. By the time it was completed in the 1640s the principles for fashioning a dome were well understood. But when the great dome of the cathedral in Florence was under way two centuries earlier, dome building was a lost art that Brunelleschi had to reimagine almost singlehandedly. In the same way, most great houses, from the villas of Palladio to the palaces of Blenheim and Versailles to the presidential estates at Mount Vernon and Monticello, though they count as some of the most beautiful and fascinating buildings in history, required no great leaps of structural ingenuity.

It's also true that engineering advances can insist upon their own new aesthetic, create their own new kind of beauty, one that the world will eventually make its peace with, then warm to, then love. This was especially true after the Industrial Revolution led to the blunt introduction of raw-looking mass-produced materials into buildings. The abrupt arrival of

the Crystal Palace in London in 1851 led to grumbling about the awfulness of a building composed of iron trusswork. It ended up a great popular success. Even before it was complete, the Eiffel Tower set off a formal protest by notable names in French culture, men who were appalled that "an odious column of bolted metal" was rising up to dominate the Paris skyline. It would, of course, become the beloved symbol of the city and, better still, synonymous with the very idea of romance.

But by the 20th century the world was undeniably caught up in what could only be called the romance of engineering. Huge skyscrapers, massive dams, miles-long tunnels and canals had all become synonymous with human aspiration, even when they sometimes exacted costs in harm to the environment or the fabric of the city. We're more aware now that mammoth building projects can produce new problems even as they solve old ones. But all of that was in the future when Walt Whitman wrote "Mannahatta," his paean to explosively growing New York. It was the late 19th century, and the upward-climbing streetscape excited him: "High growths of iron, slender, strong, light, splendidly uprising toward clear skies." You know that something has changed when the poets take time from declaiming about the mountains to start apostrophizing the skyline. More than a century later, something of that sense of awe is at work in us still.

LABOR DAYS Left to right, workers toil on the Great Pyramid; Brunelleschi presents a model to the Florentine prince Cosimo de' Medici; a worker at the Empire State Building fastens a steel cable; a miner tends to the giant drilling machine digging the Gotthard Base Tunnel in Switzerland; a Canadian astronaut positions a replacement gyroscope for the International Space Station.

1 | STANDING STONES

One of humanity's first engineering feats was to quarry massive stones, move them a long way, then set them upright and perhaps even put another massive stone on top. But how?

STONEHENGE

WILTSHIRE, ENGLAND / 3000 TO 2000 B.C.

THEY STAND ON THE SALISBURY Plain in England, about 85 miles southwest of London, but many centuries from the bustle of the city. Massive, silent, and mysterious, older perhaps than the Great Pyramids, the colossal arrangement of rock that is Stonehenge was put in place by prehistoric Britons we know very little about. The great monument they left behind makes us stand back in awe at the effort required to move its giant building blocks, some as heavy as 26 tons.

Begun in the last centuries of the Neolithic era—the New Stone Age that saw the birth of agriculture—Stonehenge is believed to have been produced in stages starting around 3000 B.C., when the circular earthen bank and canal that is its widest enclosure was laid down. The vast circles of stones—the 18- to 29-foot-high sarsens and the smaller bluestones—were moved into place beginning around 2600 B.C. Remarkably, the bluestones came from southwestern Wales, a distance of 156 miles. Most experts believe they were moved by some combination of water transport and overland hauling, using rollers, sledges, and rails, though some think Ice Age glaciers may have carried them to the Salisbury Plain thousands of years earlier.

By comparison, the sarsens were cut from a local sandstone. They were arranged in two formations, only portions of which survive. An inner horseshoe of five trilithons, a form consisting of two upright stones capped by a horizontal lintel, was surrounded by a circle of 30 standing stones, all linked by a continuous lintel. We know the workmen had tools: the stones show the marks of hammer stones and mauls. And well-crafted joints—dovetails and tongue-and-grooves—hold the lintels atop the vertical stones.

What were the circles for? In its earliest form, Stonehenge was indisputably a burial ground for cremated remains. But surely it was also some kind of ceremonial site. Most intriguing is the likelihood that it was an astronomical observatory, a means for tracking the skies. Its northeastern entrance precisely matches the position of the midsummer sunrise and midwinter sunset. For millennia, prehistoric people had watched the sun, the moon, and the stars move in repetitive cycles. Stonehenge may be a massive device that allowed them to pinpoint those movements to assist with planting and harvests—and more than that, to align themselves with the powers of heaven.

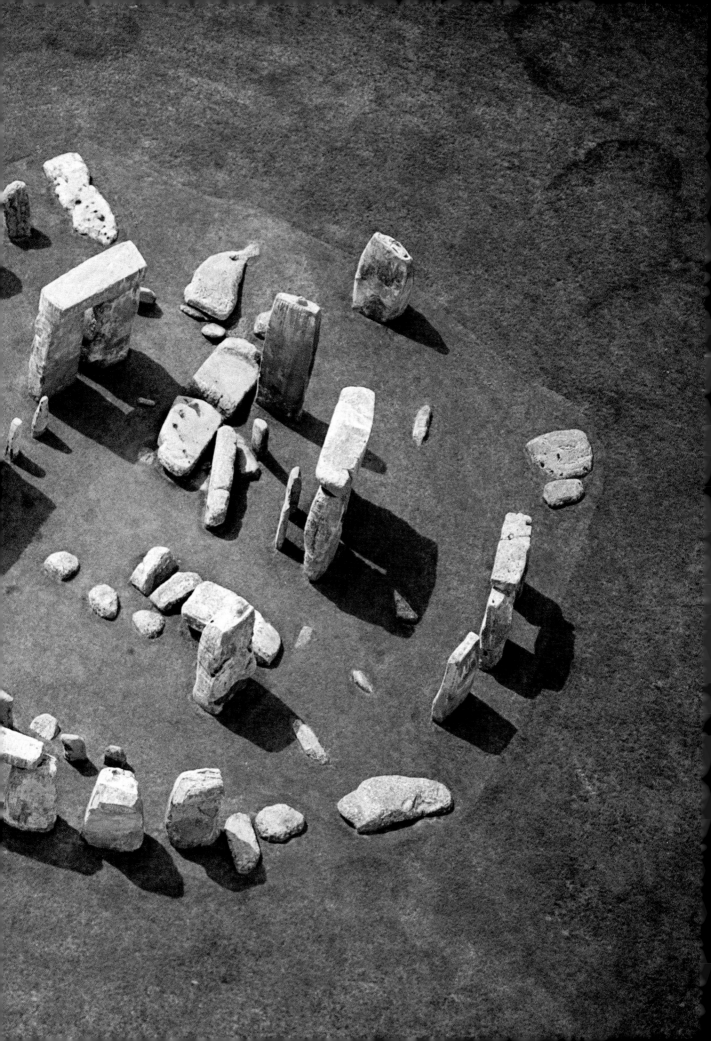

EASTER ISLAND *MOAI*

EASTER ISLAND / CIRCA A.D. 700 TO 1600

THEY ARE ALL FULL-BODY carvings, but the name most people know them by is the Easter Island heads. Impassive and even strangely anonymous, those great, implacable visages, each with its heavy brow, elongated nose, and enigmatic expression, are among the most famous faces in the world. The native word for these powerful figures is *moai,* and nearly 900 of them dot the coast of Easter Island—or Rapa Nui, as its inhabitants call it (and call themselves as well)—a 63-square-mile speck of land in the South Pacific, about 2,300 miles west of Chile, that is one of the most isolated places in the world.

Who or what do they represent? Archeologists say it's the spirits of ancestors or native chiefs who were deified after their deaths, men the islanders may have regarded as intermediaries between themselves and their gods. Carved from volcanic stone, they average around 13 feet tall and 14 tons in weight—though the largest, "El Gigante," is an imposing 72 feet and weighs between 145 and 165 tons.

Most of the *moai* are believed to have been produced in the 15th and 16th centuries, though some may date back as far as the eighth. Interestingly, fewer than 300 have been moved to their intended final sites, stone platforms called *ahus,* where several figures are typically arranged in a row, always with their backs to the sea, as if surveying the tribal lands and their descendants who continued to live there. Nearly 400 others remain in the quarry where they were carved, within the walls of the volcanic crater called Rano Raraku, many still attached to the bedrock from which they were being cut. Others lie abandoned outside the quarry, where thousands of crude basalt picks are also strewn about. Rapa Nui tradition says the *moai* that do stand upon *ahus* walked there through spirit power. But magic may not have been necessary. Experiments performed in the 1950s found that 180 islanders working together could haul a medium statue along the ground. As few as 12 could lift a 25-ton statue into an upright position using wooden logs as levers.

No one knows with certainty where the first islanders came from, though it's likely they journeyed by canoe from Polynesia, 2,600 miles away, sometime between the eighth and 12th centuries. Easter Island was the name given to the place by the first European visitor, the Dutch explorer Jacob Roggeveen, who arrived on Easter Sunday, 1722. By that time the population of Rapa Nui had dropped precipitously, to between 2,000 and 3,000, from a high of about 9,000 a century earlier. That decline was largely due to calamitous environmental change caused by deforestation carried out by the islanders themselves.

The disappearance of palms and other large trees made it impossible for the Rapa Nui to build the longboats they used for fishing. It also deprived birds of nesting places, so that many species became extinct, denying the islanders another source of protein. Warfare, in which many of the *moai* were toppled, became more common. Hunger spread. The collapse of their society may also have led the Rapa Nui to abandon faith in their ancestor-based religion. That in turn may explain why they abruptly gave up on carving the giant figures, caretakers that no longer seemed able to protect them.

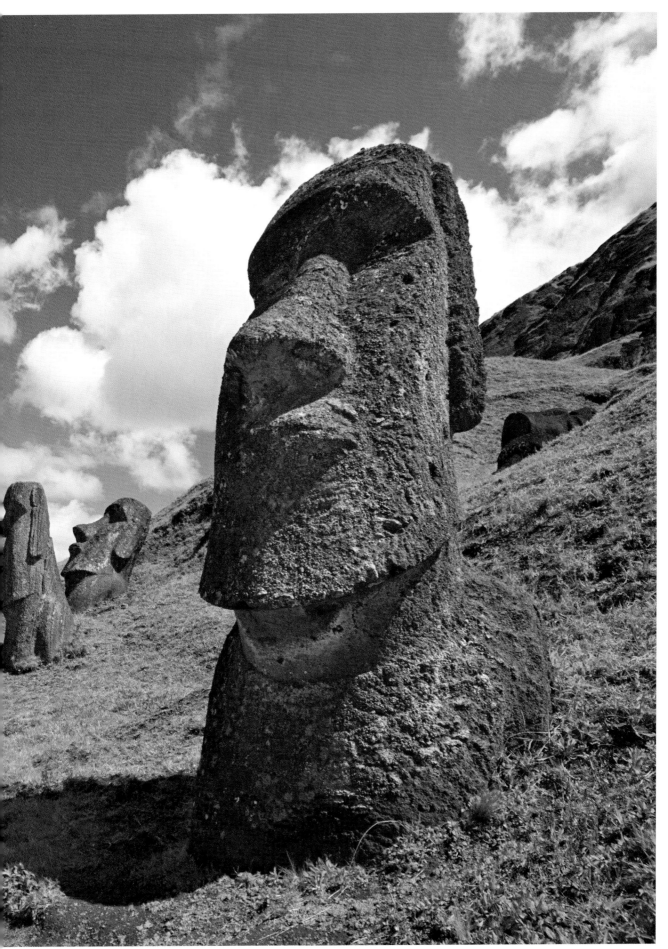

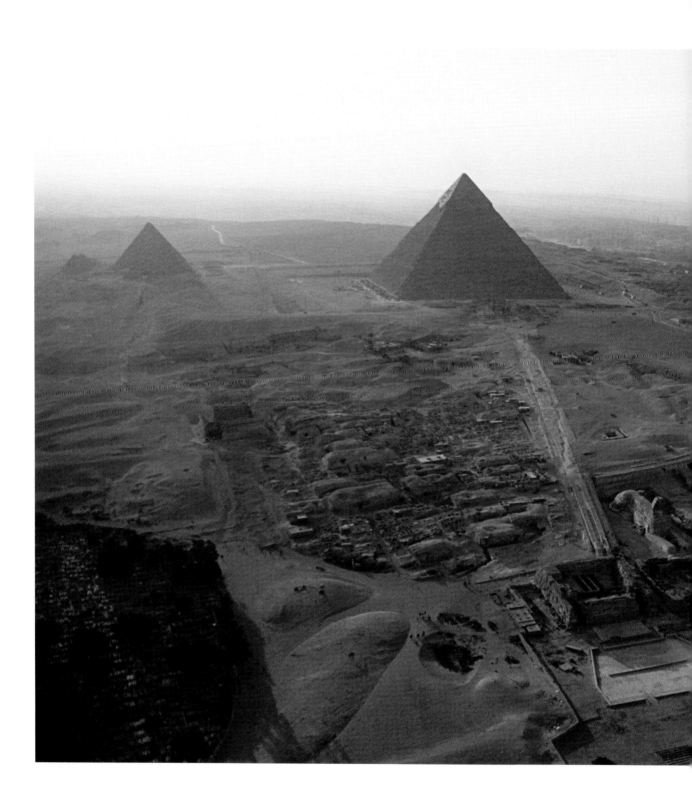

2 | PYRAMIDS

Fundamental geometric forms, they are among the earliest colossal structures. Whether built by the ancient Egyptians or by the indigenous civilizations of pre-Columbian America, they express in stone the idea of mightiness, earthbound but reaching toward the heavens.

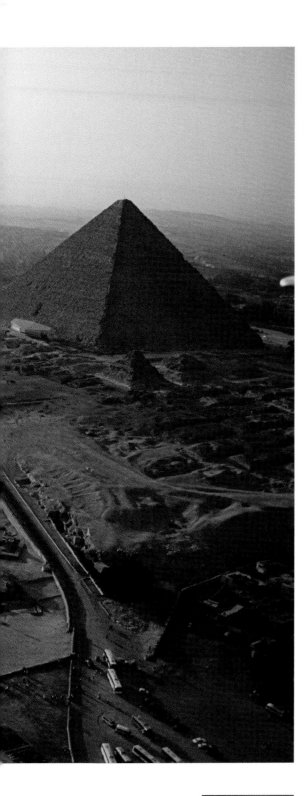

PYRAMIDS OF GIZA

GIZA, EGYPT / CIRCA 2500 B.C.

THE FOURTH DYNASTY
Pharaoh Khufu (Cheops to the Greeks) ruled Egypt in the 26th century B.C. The Great Pyramid he built at Giza, and the two beside it that were added by his successors Khafre and Menkaure, are the last surviving examples of the original Seven Wonders of the World. To this day they rank among the largest structures of all time. All three are monuments to the Egyptian obsession with the afterlife: giant tombs, each constructed to house the burial chamber of a single pharaoh, containing not only his mummified remains but also the hoard of personal effects—the household goods, jewelry, and statuary—that would allow his soul to enjoy its eternal stay in the next world.

As one writer has pointed out, so vast is the footprint of the Great Pyramid that the cathedrals of Florence and Milan, St. Peter's in Rome, and St. Paul's and Westminster Abbey in London could all be placed together within it. At 450 feet it was the tallest structure in the world until A.D. 1311, when the tower of Lincoln Cathedral in England surpassed it. It was originally almost 30 feet higher, but over the centuries quantities of stone were pillaged from the top. The polished limestone that once dressed the entire exterior, and made the sides of the pyramids a single smooth plane from top to bottom, has

also been stripped away, some of it to build the mosques of later Muslim rulers, exposing the rougher stone beneath and giving the pyramids the stair-step silhouette they have today.

Many Egyptologists believe it was Khufu's son Khafre, builder of the second pyramid, who also ordered up the Sphinx, a massive stone lion with the head of a man, probably Khafre himself. Sixty-six feet high, 240 feet long, it was carved from a solid outcropping of limestone on the Giza plateau, with limestone blocks added.

How was it that people who had not invented the wheel—even the pulley and the screw were unknown to them—were able to haul roughly 2.3 million blocks, some weighing as much as nine tons, from quarries many miles distant and then raise them hundreds of feet in the air? We can only speculate, but it seems likely that after being cut from the plentiful limestone ledges of the Upper Nile, or from granite quarries at Aswan, the blocks were transported by river barge to Giza. Many experts believe that as the vast structure rose there, the Egyptians built all around it a sloping embankment of brick, soil, and sand, increasing its height as the completed portions of the pyramid climbed. The blocks could be pushed and hauled up the slope on sledges or rollers, then fitted into place.

In recent years, however,

IMHOTEP
A commoner who rose to be councilor to the Third Dynasty Pharaoh Djoser, Imhotep is the first architect-engineer we know by name. He designed the world's first monumental structure, the Step Pyramid at Sakkara, a prototype for the later pyramids at Giza.

Jean-Pierre Houdin, a French architect who has spent more than a decade studying the Great Pyramid, has put forth an intriguing and much-discussed alternative idea. He suggests that a long, straight external ramp was used to deliver stones only for the lower third of the pyramid. Meanwhile, a second ramp was built inside the pyramid to deliver materials for the upper two thirds—a ramp that is still there, hidden inside the structure.

Though they may have lacked modern tools, one thing the Egyptians had plenty of was manpower, whether in the form of slaves or agricultural workers recruited for service after the harvests. Tens of thousands labored on the pyramids, each of which was built in under 20 years—well in time to receive the pharaohs who ordered them.

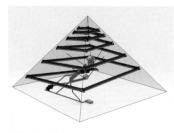

INSIDE TRACK In the theory developed by Jean-Pierre Houdin, the building blocks of the pyramid were moved into place along a spiraling internal ramp.

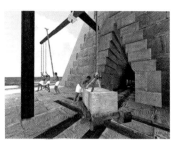

SHARP TURN Wooden hoists inserted into notches could have been used to turn blocks onto the next part of the internal ramp.

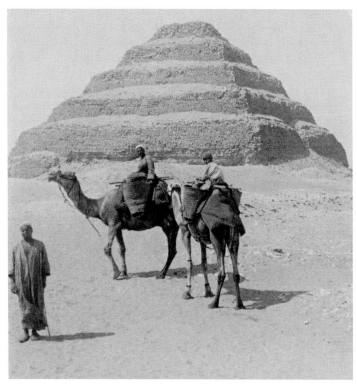

A MAJOR STEP The so-called Step Pyramid at Sakkara, designed by Imhotep for the Pharaoh Djoser, was the first monumental stone building in ancient Egypt—and perhaps the world. Built around 2650 B.C., it rises in six stages to a height of 200 feet. It opened the way to the design of the pyramids at Giza a century and a half later.

TEMPLE OF THE GREAT JAGUAR

TIKAL, GUATEMALA / CIRCA A.D. 740–750

THE REGION OF TROPICAL RAIN forest in northern Guatemala known as the Petén Basin was once the center of Mayan civilization, a complex and creative society that enjoyed a golden age from about the second century A.D. to the 10th. Then came "the collapse," a rapid decline brought about by some combination of chronic warfare, natural disasters, and deforestation that led to drought, the collapse of agriculture,

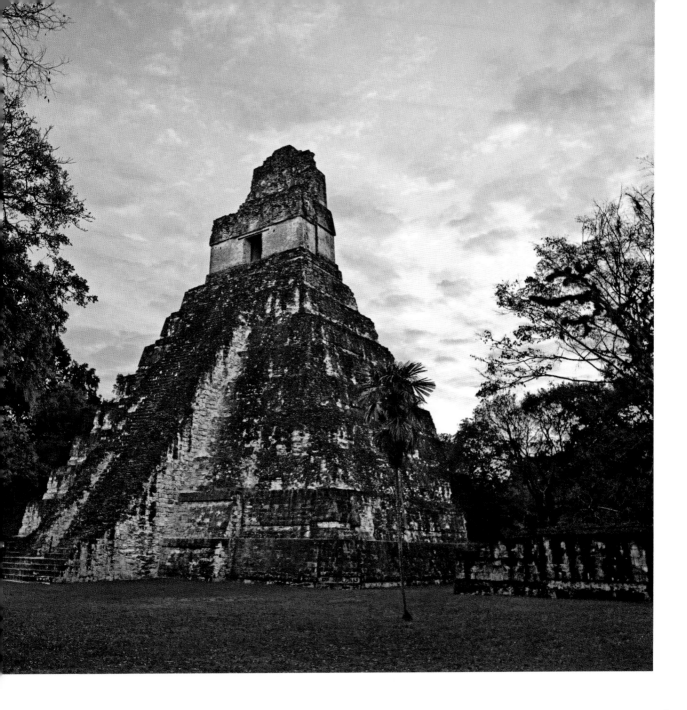

and famine. In a remarkably short time the Mayan population plummeted by 90 percent or more. Their great cities were deserted and swallowed up by the rain forest, known only to local inhabitants until they were rediscovered by the wider world in the 19th century.

But during the many years in which their culture flourished, the Maya developed an elaborate and richly decorated ceremonial architecture. They built vast palace and temple complexes presided over by stair-step limestone pyramids. Tall enough to rise above the jungle canopy and serve as landmarks,

the pyramids were both worship centers and royal tombs, with "roofcomb" temples at their summits and burial chambers within that were ornamented with painted murals and carved friezes. Lacking metal tools, the Maya worked with blades and implements made from obsidian, a form of volcanic glass.

One of the largest Mayan urban centers was Tikal, a city that at its height had as many as 90,000 inhabitants and numerous monumental pyramids. In the city's Great Plaza two of them face one another across the open square. Temple 1,

or the Temple of the Great Jaguar, served as the tomb of Jasaw Chan K'awiil, one of the greatest Mayan warrior-kings, who ruled Tikal from 682 to 734. Rising to a height of 145 feet, it was once crowned by a giant statue of the king, now largely gone. A remarkable feature of both pyramids is found in the temples at the top, where depressions cut into the stone serve as voice amplifiers, so that someone speaking from the pinnacle can be clearly heard some distance away. But the Maya abandoned these sacred precincts centuries ago, and we strain now to hear their lost voices.

3 | MADE FROM MOUNTAINS

From ancient Egypt to 20th-century America, it's been an irresistible challenge to carve giant figures or even whole buildings from the earth itself, or to embed them beneath a rock overhang.

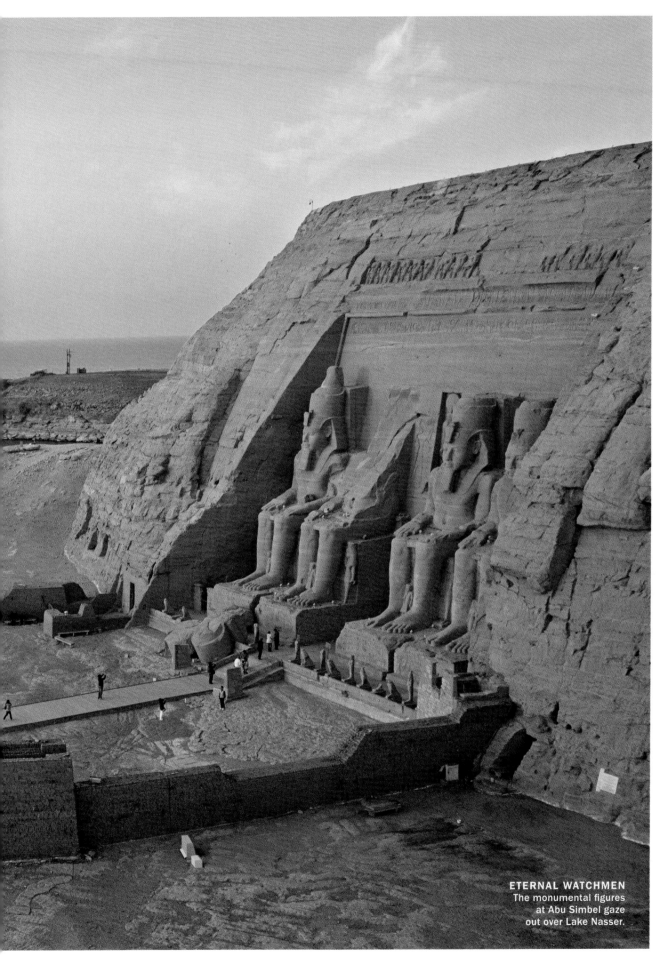

ETERNAL WATCHMEN
The monumental figures
at Abu Simbel gaze
out over Lake Nasser.

ABU SIMBEL

LAKE NASSER, EGYPT / 13TH CENTURY B.C.

THE PAIRED TEMPLES AT ABU SIMBEL WERE A TRIUMPH OF HUMAN ingenuity twice—first when they were carved from a sandstone cliff on the banks of the Nile in the 13th century B.C., and again in the 1960s, when they were cut apart and hoisted away to save them from the waters of Lake Nasser, a reservoir created by the Aswan High Dam.

They were built by the Pharaoh Ramesses II, who ruled Egypt from 1279 to 1213 B.C. Four colossal seated figures, each 66 feet tall, flank the doorway of the larger temple—all representing him. (The adjacent smaller temple is devoted to his favorite wife, Queen Nefertari.) Inside the Temple of Ramesses, an enfilade of halls and chambers projects 185 feet into solid rock, oriented, like Stonehenge, to capture a cyclical solar event. Twice each year, around February 22 and October 22, the morning sun penetrates the full length of the interior and strikes four statues of the gods on the rear wall of the innermost shrine.

Over time the temples were engulfed by the desert, but they were rediscovered in 1813 by the Swiss explorer J.L. Burckhardt, who just the year before had discovered Petra. (Legend has it that Abu Simbel was the name of the Arab guide who led him to the site.) In the 1960s, with Lake Nasser on the way, a $40 million rescue project was funded by the Egyptian government and UNESCO. It required an unprecedented feat of archeological levitation—cutting the massive structures into more than 10,000 blocks, hauling those to a site more than 200 feet higher and 650 feet away, then smoothly cementing them back into place and surrounding them with an artificial mountain. Completed in 1968, it was a job that gave new meaning to the term "high and dry."

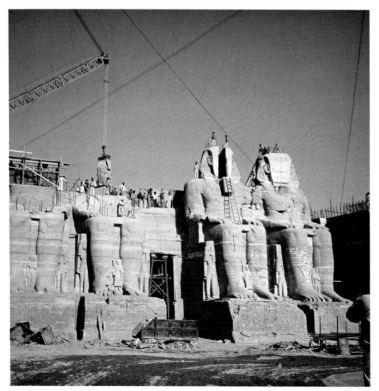

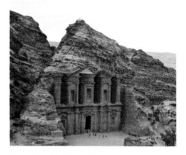

PETRA

JORDAN / 100 B.C.
TO A.D. 100

VISITORS APPROACH PETRA THROUGH a narrow, winding gorge almost a mile long. At its final bend, it frames the first sight of the city like parted curtains. Then a magnificent structure emerges fully into view. Al Khazneh ("The Treasury") is the most spectacular remnant of the ancient city of Petra, whose name derives from the Greek word for stone. It's a fitting term, because this great settlement, whose surviving parts include an amphitheater, a temple called "the Monastery" (seen above), and dozens of tombs, is built and carved directly into solid rock.

Petra was the capital of the Nabateans, traders whose caravans brought spices from Arabia and India to the Mediterranean and Egypt and whose city was in time absorbed into the Roman Empire. The Treasury tells us something of the riches of their culture. Almost 150 feet high, its inner chambers reach deep into the sandstone cliff. Because it is a single carved unit, the columns that appear to support its great lintel serve as an illusion. Even the ones at the center, those cut entirely free of the rock face, are not load-bearing—the lintel above them is a shelf held firm by the cliff from which it was made.

UPLIFTING
The temple and its threshold figures being relocated.

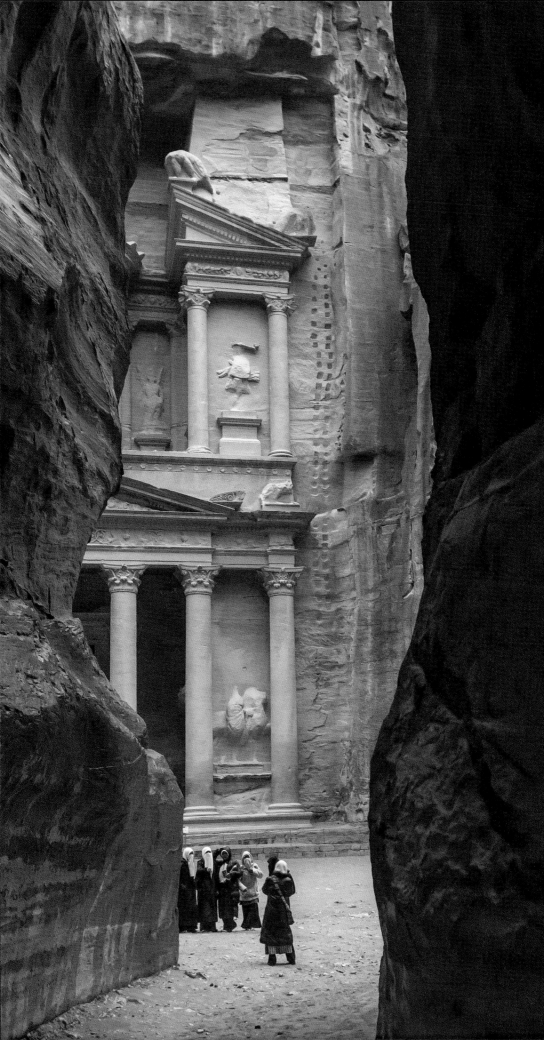

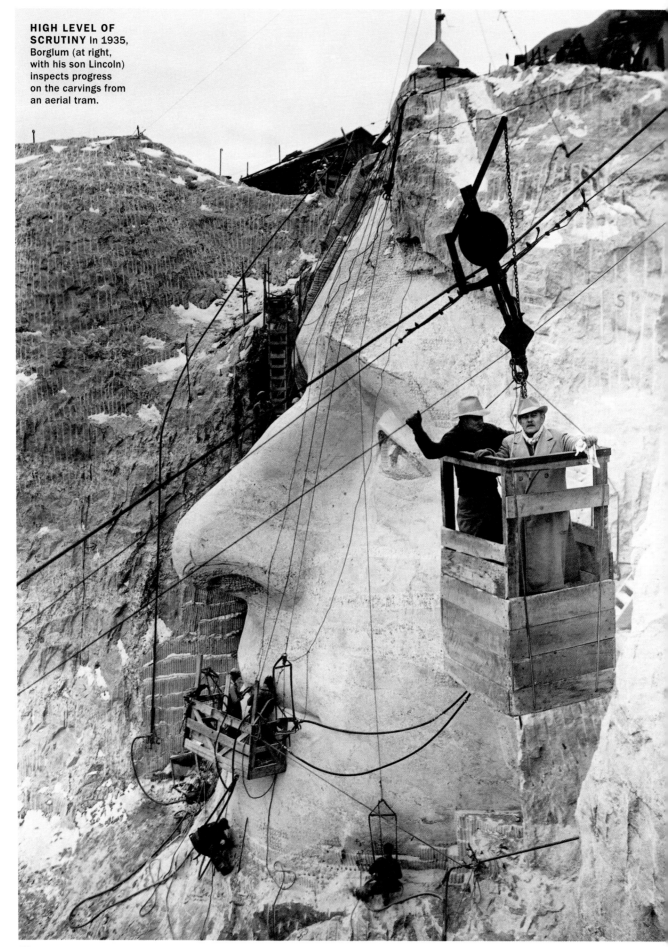

HIGH LEVEL OF SCRUTINY In 1935, Borglum (at right, with his son Lincoln) inspects progress on the carvings from an aerial tram.

MOUNT RUSHMORE

BLACK HILLS, SOUTH DAKOTA / 1927 TO 1941

IN THE FIRST HALF OF THE 20TH century, as America became a world power, a massive carving commensurate with its rising status emerged on a Midwestern mountain peak. You could call it an exercise in democratic monumentalism. It was grander than anything made by Egypt or Rome, but the men it represented, with heads 60 feet tall, were not pharaohs or emperors but elected leaders, a quartet of American presidents.

Though it required scores of workers to do the blasting and finer carving, Mount Rushmore was essentially the creation of one man, a combative Danish-American sculptor, Gutzon Borglum. In the early 1920s he had carved a likeness of Robert E. Lee into a mountain face in Georgia. News of that project prompted Doane Robinson, South Dakota's state historian, to ask Borglum to do something similar in the Black Hills. Robinson had in mind a local hero like Buffalo Bill or Chief Red Cloud. Borglum insisted that only presidents would do. Practical Dakotans snorted at the estimated cost, but in time it attracted the blessing of President Calvin Coolidge and federal matching funds from Congress.

Borglum recruited a workforce of rough miners to go at the mountain with jackhammers, blasting away to produce first a surface where the features of George Washington emerged. Serious problems cropped up soon after with Thomas Jefferson, originally planned for Washington's right. Because the stone there proved too soft, 18 months of drill work had to be dynamited away.

When private donations dried up in the worsening Depression, Congress rescued the project, but handed it to the National Park Service, whose overseers Borglum squabbled with constantly as he moved on to Theodore Roosevelt and Abraham Lincoln. After his death in 1941, when his son took over to supervise the final touches, funding proved insufficient to extend the four figures from head to waist, as Borglum had intended. But the heads alone were enough to capture the national imagination and to make Mount Rushmore, as he had hoped, America's skyline.

THE SCULPTOR

GUTZON BORGLUM

Borglum was born in St. Charles, Idaho, in 1867. His Danish immigrant father was a polygamous Mormon, and his mother one of two sisters he wed. By 1884 the elder Borglum had embraced monogamy, shed the boy's mother, and moved his family to Los Angeles from Nebraska. Though they soon returned, young Borglum stayed behind to study art. During a trip to Paris, a meeting with Auguste Rodin persuaded him to become a sculptor. When one of his works, a large marble head of Abraham Lincoln from 1908, proved a great success, it led to numerous commissions for public sculptures, as well as one to carve a giant figure of Robert E. Lee on Stone Mountain in Georgia—a project that apparently led him to join the Ku Klux Klan. He was a flawed man, vain and belligerent, but his energies were enough to literally move mountains.

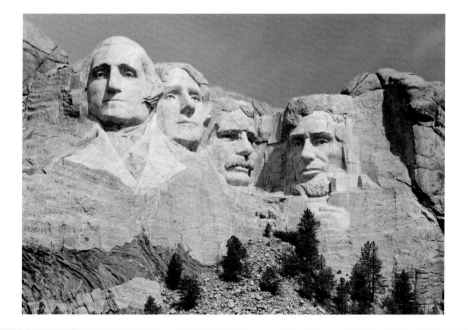

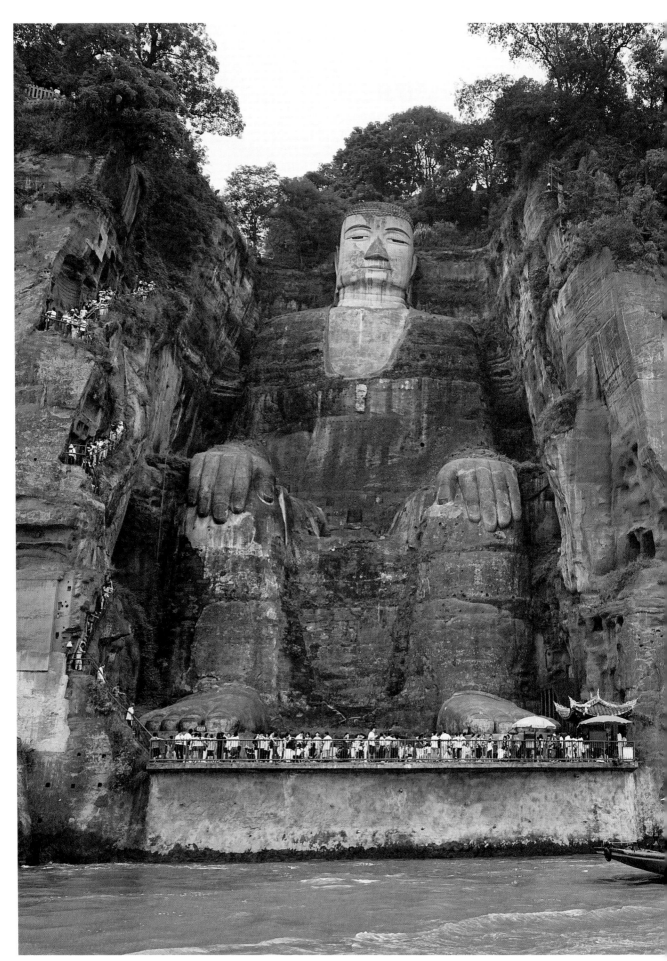

LESHAN BUDDHA

LESHAN, CHINA /
A.D. 713 TO 803

IN SOUTHERN SICHUAN PROVINCE, where the Leshan Giant Buddha gazes impassively from its cliffside niche, they have a saying: "The mountain is a Buddha, and the Buddha is a mountain." It's easy to see what they mean. At 233 feet, the Leshan figure is the world's tallest Buddha. Taking its name from the nearby city of Leshan, it faces Mount Emei, a complex of sanctuaries that's one of Buddhism's holiest sites. It also sits at the juncture of three rivers, and it's said that Haitong, the Buddhist monk who began the sculpture, in A.D. 713, hoped Buddha might calm the turbulent waters that made river commerce perilous.

Haitong could not attract enough financing to finish the work. (In a vain effort to dramatize the sincerity of his mission, he is said to have gouged out his own eyes.) After his death, a local governor saw it to completion. Just as Haitong had hoped, the production of the Leshan giant did indeed calm the waters below, but the intervention of Buddha may not have played any role. The carving created an abundance of rubble that accumulated on the riverbed, altering the currents and leading to a calmer flow.

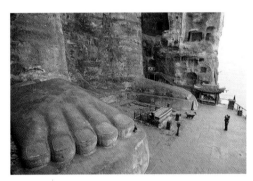

BIGFOOT Visitors take in the Buddha's massive toes. Concealed drainage channels in his hair, collar, and chest deter rainwater erosion.

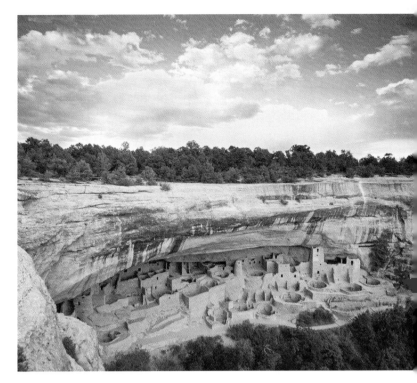

ANASAZI CLIFF PALACE

MESA VERDE NATIONAL PARK, COLORADO /
LATE 12TH CENTURY

ONE OF THE MOST INTRIGUING CULTURES TO DEVELOP IN North America before the arrival of the Europeans was the Anasazi. Inhabitants of the lands where Colorado, Utah, Arizona, and New Mexico converge, they flourished for centuries—then, in the space of a few decades, abandoned the complex places they had built. Though they began as nomadic hunter-gatherers, wandering the arid region as early as 1500 B.C., by the seventh century A.D. they had started to practice agriculture regularly and to form settled communities. In time they began to build multistoried stone structures, ancient apartment complexes that could have hundreds of rooms.

In the 12th and 13th centuries, perhaps as a way to protect themselves from enemies, the Anasazi took to building their communities high up on cliffs or nestled beneath protective rock overhangs. Cliff Palace is one of the most spectacular of these enclave constructions, which were not carved from the cliffs but built within their niches. With 150 rooms and 23 *kivas* (underground chambers), it housed about 100 people and may also have served as an important center for social and ceremonial activities.

What became of the Anasazi is not clearly understood. Twenty-three years of drought that began in 1276 may have led to famine, internecine warfare, and even cannibalism. Raiders may also have arrived from outside the region to drive them away. What we do know is that by 1300 they had emptied out of their settlements and scattered south and east. Though present-day Pueblo peoples, including the Utes, Hopi, and Zuni, are considered their descendants—and disdain the name Anasazi, preferring to call their ancestors the Ancient Pueblo—the civilization that created the spectacular cliff dwellings came to a swift and mysterious close.

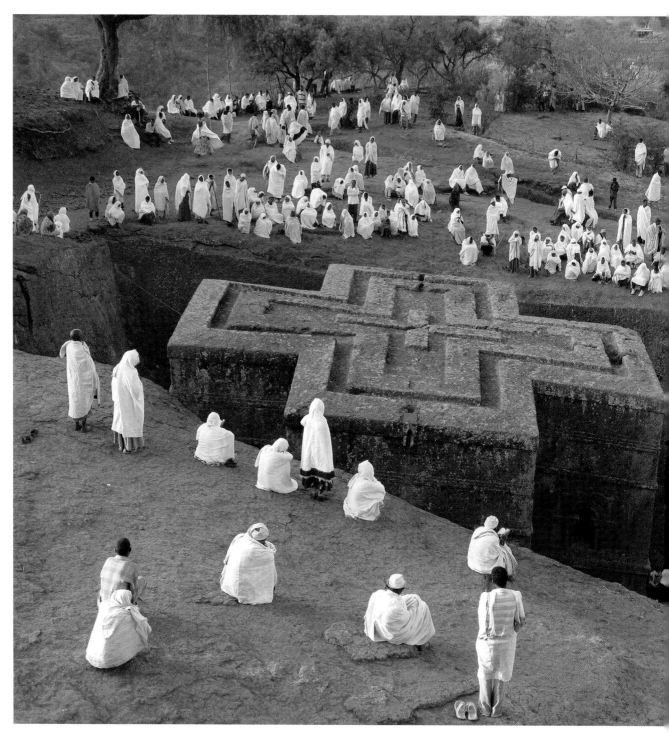

CHURCH OF ST. GEORGE

LALIBELA, ETHIOPIA / 13TH CENTURY

CHURCHES CAN INSPIRE FEATS OF extravagant construction, like the great Gothic cathedrals. But some of the world's most remarkable churches are relatively simple structures made in an extraordinary way.

In Lalibela, a small town in northern Ethiopia, are 11 rock-hewn churches, all of them carved below ground level from red volcanic bedrock. Still active as sites of religious service and pilgrimage, they

were commissioned by the 13th-century Ethiopian king Lalibela. To gain favor with the powerful Ethiopian Orthodox Church, he hoped to build a New Jerusalem. For each church, workers first dug a deep excavation, leaving a large solid block at its center. Then stonemasons laboriously hollowed out the block with hammers and chisels, also cutting windows, doors, and stairs. Though not the largest, the Church of St. George is the

best preserved. Sited in an excavation 40 feet deep, it takes the shape of a Greek cross, with equilateral crosses cut into its roof.

Whether King Lalibela's piety was sincere when he began his would-be Jerusalem, the decades-long effort of church building seems to have struck a chord within him. After laboring on the project for 20 years, he abdicated his throne to become a religious hermit.

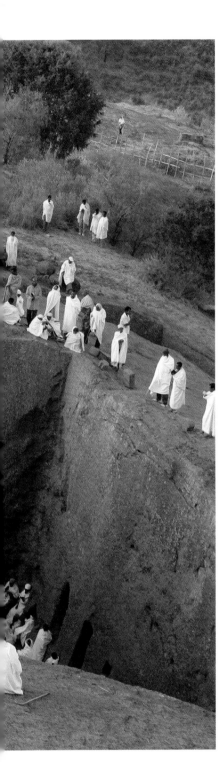

CONFEDERATE MEMORIAL CARVING

STONE MOUNTAIN, GEORGIA / 1923 TO 1972

THE AMERICAN CIVIL WAR LASTED FOUR YEARS. THE VAST monument to the Southern side took much longer. By 1909, C. Helen Plane, a member of the United Daughters of the Confederacy, had the idea for a memorial to Gen. Robert E. Lee on Stone Mountain, northeast of Atlanta. What she wanted for the massive cliff face was a bust-length relief of Lee alone. Her chosen sculptor, Gutzon Borglum, later famous for Mount Rushmore, told her that would be like pasting a postage stamp on a barn door. His own vision was grander: a frieze of seven figures, accompanied by "an army of thousands."

Work got under way in 1923, and Borglum's Lee was ready the next year. But his contract was soon canceled amid accusations about his "wasteful expenditures" and "ungovernable temper." His successor, Augustus Lukeman, reconceived the monument to include Lee, Confederate President Jefferson Davis, and Gen. Stonewall Jackson, all on horseback. He had Borglum's work blasted away entirely.

By 1928 work had stopped again, this time because of a lack of funds and problems in renewing a lease on the cliff face. It was not to be resumed until 1964, near the centennial of the war's conclusion. A third artist, Walker Hancock, completed it to Lukeman's plan. Measuring 90 by 190 feet, it's the largest relief sculpture in the world. No one mistakes it for a postage stamp.

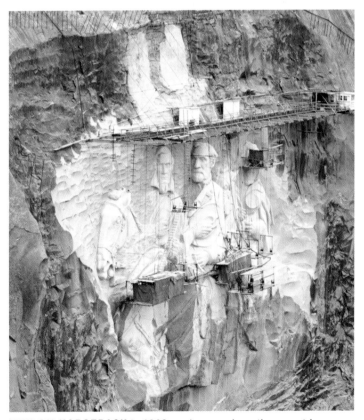

MEN ON HORSEBACK In 1968, work proceeds on the equestrian images of Jefferson Davis, Robert E. Lee, and Stonewall Jackson.

4 | FORTIFICATIONS

They weren't built for beauty. They were built for strength, to repel invaders and to withstand sieges. Yet the world's great fortresses and protective walls can have the beauty that implacable structures convey, created to fulfill the most serious purposes.

MASADA

JUDEAN DESERT, ISRAEL / 37 TO 31 B.C.

MASADA—THE NAME IS HEBREW for fortress, but the isolated mesa high above the Dead Sea has been remembered down the centuries as something much more than that. Though the first people to build a citadel there may have been the Hasmoneans, who ruled Judea in the second and first centuries B.C., the Roman-appointed King Herod remade their desert outpost into a lavish compound of palaces and fortifications. His residence there was the majestic "hanging palace," built on three terraces that step down the mesa's north face and connect by narrow stairways cut into the rock. An ingenious system of cisterns collected rainwater. But Herod was an unpopular leader, forced upon his Jewish subjects by the Roman Senate. So Masada was more than a royal retreat. His fear of armed revolt led him to enclose the summit with a fortress wall with 27 towers.

More than six decades after his death, during the Jewish rebellion against Roman rule that began in A.D. 66, Jewish zealots seized and occupied the site. Other rebels and their families joined them. Six years later, the uprising close to defeat, the Roman governor Flavius Silva dispatched a legion to retake what was by then the last remaining Jewish stronghold. To do so required the Romans to construct a network of siege camps along the base and a massive ramp of stone and packed earth that climbed to the top of the mesa. Up that ramp they moved a siege tower with a battering ram sufficient to breach Herod's walls. But though they would overrun the fortress, they would not capture its Jewish defenders, who had decided upon a last desperate act—a suicide pact. Rather than surrender, they would sacrifice their lives. The Romans arrived at the summit to find nearly all the 960 men, women, and children there dead, ensuring that the name "Masada" would come down to us not just as a word for fortress but as a byword for defiance.

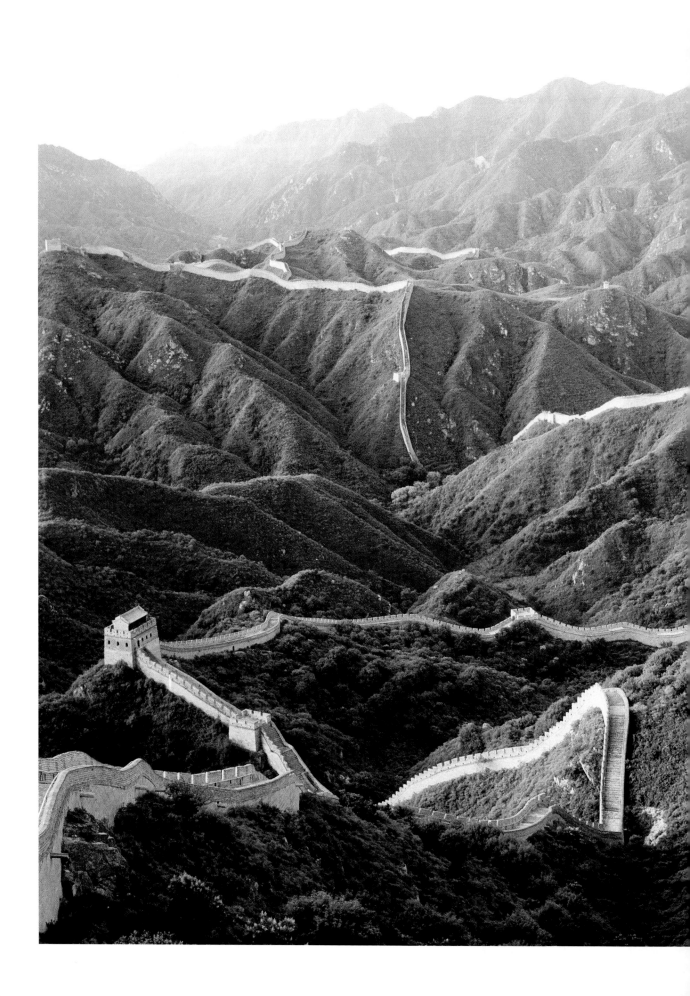

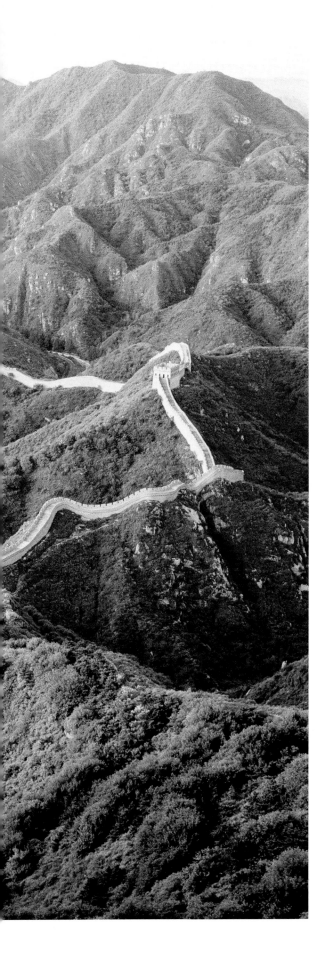

THE GREAT WALL

SHANHAIGUAN TO JIAYUGUAN, CHINA /
SEVENTH CENTURY B.C. TO 17TH CENTURY A.D.

———

BOUNDING ACROSS THE LANDSCAPE OF CHINA FOR almost 5,500 miles, the Great Wall is without doubt the world's largest man-made structure. For centuries it served—and sometimes failed to serve—as a bulwark against foreign invaders from the north. A magnificent system of walls, fortresses, signal towers, and gates, it had elevated roadways, about 25 feet high for much of its length, that allowed the quick movement of soldiers and couriers across the country-side. More than just a wall, it grew into a superhighway.

It had its beginnings in the turbulence of the centuries before China was unified under the First Emperor. As early as the seventh century B.C. a succession of squabbling Chinese states erected barriers to resist incursions by their neighbors. After Qin Shi Huang became the First Emperor in 221 B.C., he demolished the walls that separated the newly conjoined states of his empire. But he also incorporated other walls into a lengthy new one that he built along the empire's northern frontier to protect it from nomadic raiders. Hundreds of thousands of soldiers and forced laborers were drafted into the project, which consumed the energies of Qin's short-lived dynasty.

After his death, the wall he built fell into disrepair. But the Han Dynasty, which followed his, embarked on wall-building projects of its own, as did later dynasties. The Great Wall that we see today, however, is largely the work of just one, the Ming Dynasty, which ruled China from 1368 to 1644. Ming emperors devoted themselves to strengthening and extending the wall to keep out Mongol and Manchu invaders, using durable brick and stone as their building materials instead of the decay-prone rammed earth favored by earlier dynasties. Today the Great Wall no longer has a military purpose, but it serves China's interests in a different way: instead of keeping foreigners out, it brings them in—as tourists.

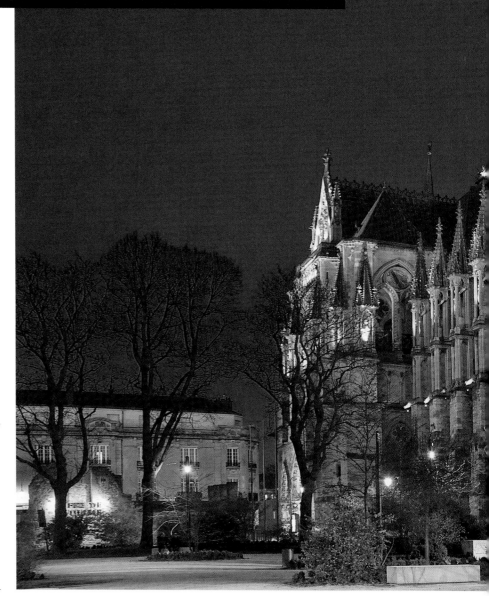

5 | MEDIEVAL CATHEDRALS

It's been called the Gothic revolution: a wave of structural and aesthetic developments that swept Europe in the Middle Ages, producing churches with soaring interiors and a thrilling abundance of light.

THE BUILDERS OF THE GREAT cathedrals of the Middle Ages never called their work Gothic. That name wasn't coined until the 15th century, when it emerged as a pejorative term for anything crude and rustic. Ironically, we use it now to describe some of the most spectacular creations of European civilization. But when it got under way in the mid-12th century, the style we call Gothic was referred to simply as the French style. It was also called *novum opus*—"new work," which in so many ways it was.

The pivotal figure in the birth of Gothic style was not an architect or engineer—as formal professions, those were still unknown—but a powerful clergyman, Abbot Suger, a friend and adviser to King Louis VI. In 1122 he became head of the abbey church of Saint-Denis near Paris, where he had served since boyhood and which he devoted himself to remodeling in a process that began around 1137. For Suger, faith was almost literally a matter of enlightenment, an upward quest toward light. Influenced by neo-Platonic

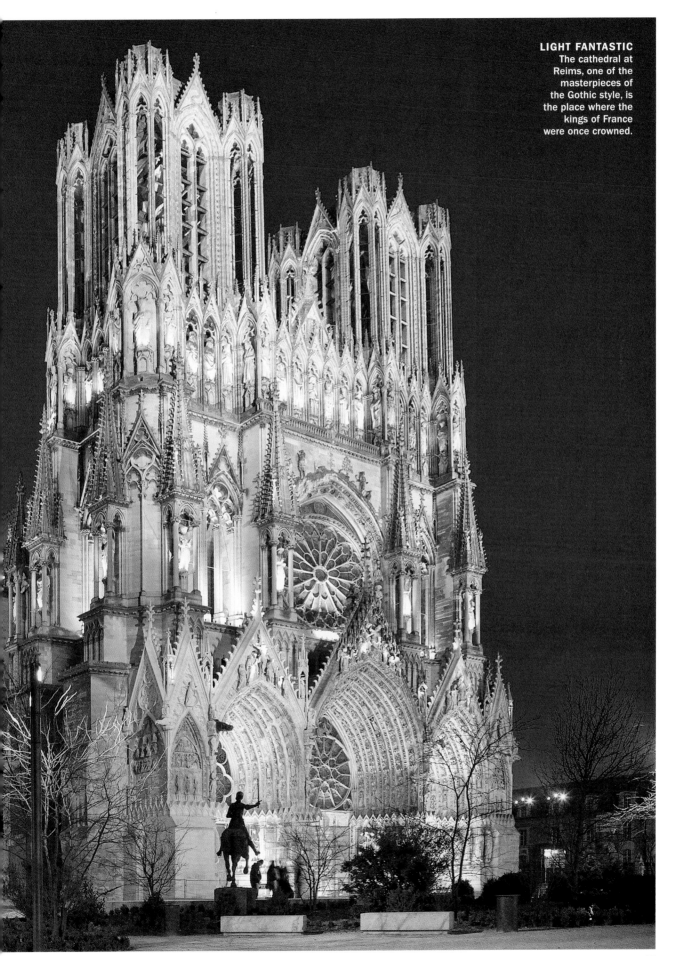

LIGHT FANTASTIC
The cathedral at
Reims, one of the
masterpieces of
the Gothic style, is
the place where the
kings of France
were once crowned.

philosophers, he believed that God was the Father of Lights and Christ the "first radiance." The material substance of the world was likewise a reflection of the divine light and could be a means for the faithful to seek God. As he put it in an inscription on the new west façade of his church: "The dull spirit rises up through the material to the truth, and although he was cast down before, he arises new when he has seen this light." So one of his innovations at Saint-Denis was to remove the walls from the chapels that radiated out from the choir so that light from their windows penetrated the church.

As Gothic architecture spread across Europe, light would remain its central preoccupation, becoming almost a building material in itself. Churches of the centuries just prior to these developments, produced in a style we now call Romanesque, were likely to be thick-walled, with rounded arches and a multitude of dark recesses. Gothic construction produced new possibilities of uplift and brightness. A sense of spatial liftoff was achieved by pointed arches, a structural device first used in the Islamic world and perhaps introduced into Europe from there, and by ribbed vaults, especially long barrel vaults that created a continuous flight of space punctuated at regular intervals by elegantly intersecting ribs. In other places, freestanding columns might support richly molded ribs springing in several directions. To permit the introduction of relatively thin walls in cathedrals that still had to carry a heavy roof, flying buttresses were added to church exteriors. Transferring the burden diagonally to vertical buttresses that carried it to the ground, they were load-bearing devices with a billowing visual rhythm all their own.

Delicacy became the byword of cathedral design. Exterior walls were penetrated by large areas of tracery—decorative patterns of stonework in slender borders and fine mullions—that framed even lighter expanses of stained glass. On the broad cathedral fronts, huge circular windows, giant discs of color, became the norm. In what could paradoxically be called a tour de force of lightness, the upper chapel of La Sainte-Chapelle in Paris, completed in 1248, is enfolded by walls that seem almost to disappear entirely, giving way to tall reaches of stained glass that run nearly from floor to ceiling.

After the refashioned Saint-Denis was dedicated in 1140, the Gothic style spread quickly, first around France, then jumping to England and all around the continent. In little more than a century many of what are now the best-known examples were completed or in progress, including Notre-Dame de Paris, Reims and Chartres in France, Lincoln and York Minster in England, Cologne in Germany, and Burgos in Spain. The cathedrals were community projects, not things ordered up by kings and emperors. All across Europe, people were emerging from the poverty, ignorance, and isolation of the Dark Ages. Newly prosperous cities were growing, and the exuberant tall churches embodied a rising spirit of cultural reawakening. Though authorized by the church hierarchy, the cathedrals were often sought by leading citizens as symbols of civic pride, financed partly by donations and built by skilled laborers who flocked to the sites to be part of a great municipal endeavor. With the Renaissance on the horizon, this was new work for what was truly a new time.

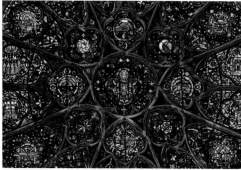

NEW WORK The Rose Window at Reims Cathedral (left) is a webwork of stone tracery and stained glass. At Notre-Dame de Paris (below), flying buttresses brace an exterior wall. The choir of Saint-Denis (right), with its ribbed barrel vault, pointed arches, and multiple windows, epitomizes Gothic design.

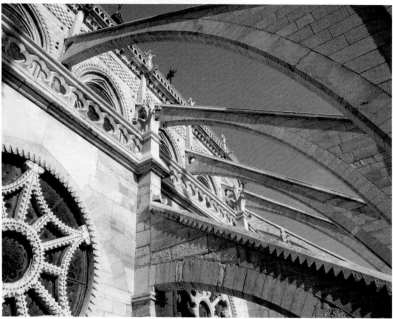

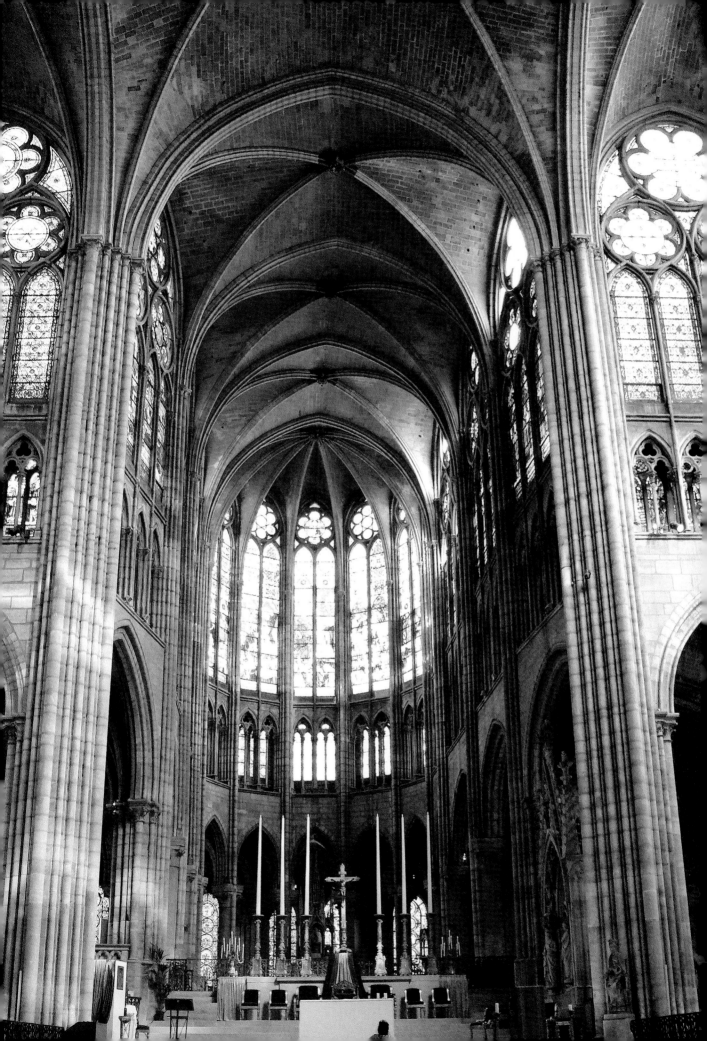

6 | GREAT DOMES

For more than 2,000 years, domes have created soaring enclosures that lift the eye and the spirit through the use of simple but powerful geometric forms—the circle, the oval, and the sphere.

PANTHEON

ROME, ITALY /
CIRCA A.D. 126

BUILT BY THE EMPEROR
Hadrian, the Pantheon is the
only sizable example of Roman
classical architecture to survive
intact into modern times. While
other great structures were
pillaged for their materials or
simply left to decay, the
Pantheon, which began life as
a temple devoted to all Roman
gods (in Latin, *pan* means all,
and *theon,* gods), had the good
fortune to be consecrated as
a church in the seventh century,
assuring it a degree of essential
maintenance.

The Pantheon's magnificent
masonry dome, 142 feet in
diameter, remains to this day
the largest ever built. Its
fundamental material is
concrete, that essential Roman
invention, poured between
layers of brick and faced on the
interior with marble. To keep
the dome's weight to a manage-
able 5,000 tons, in the upper
portions the concrete is mixed
with lighter aggregates like
pumice and even empty jars.
To further reduce the load the
walls are cut with a vivid
pattern of recessed coffers. They
are also thicker at the base, a
width of about 20 feet, dwin-
dling to about four feet near the
top. That's where you find the
Pantheon's most audacious
feature: the oculus, a 30-foot-
wide circular opening through
which light descends, deposit-
ing itself as a pool that moves
slowly across the patterned
marble floor as the sun makes
its daily transit. A simple but
strangely powerful disk, it's the
ultimate window onto infinity,
an eye on the sky.

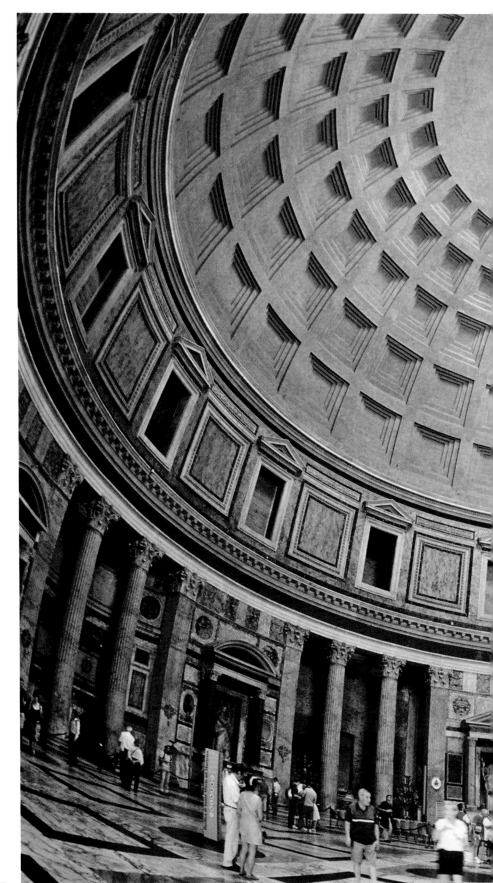

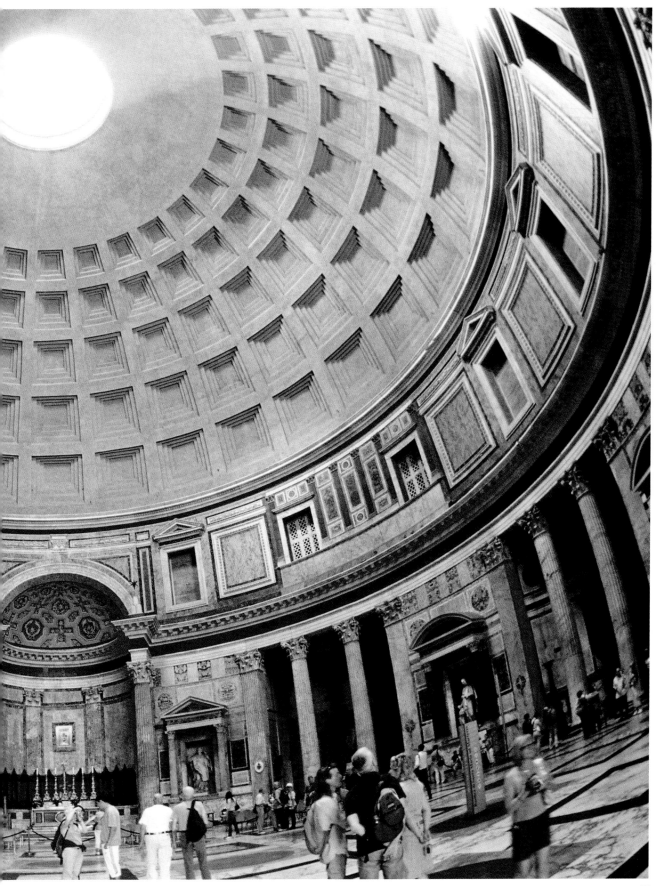

HAGIA SOPHIA

ISTANBUL, TURKEY /
A.D. 532 TO 537

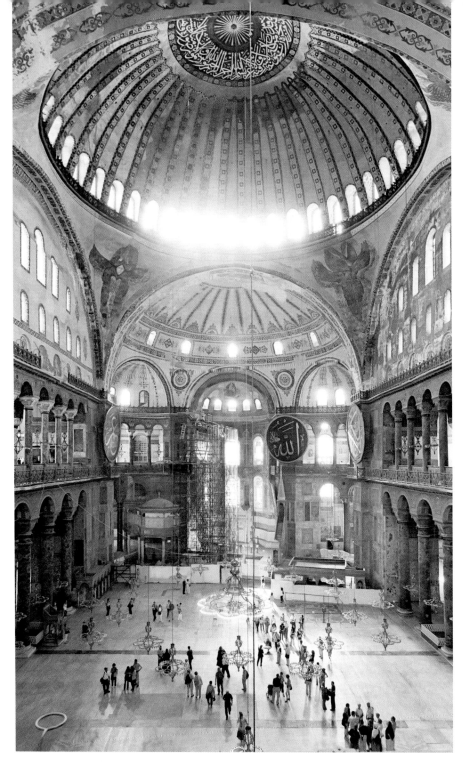

TAKE ONE LOOK INSIDE THE church that the Byzantine Emperor Justinian commissioned in A.D. 532 and you understand why, when he dedicated it just five years later as Sancta Sophia ("Holy Wisdom"), he made an imaginary boast to the king of Israel who built the First Temple: "Solomon, I have surpassed thee."

Justinian was a great builder, and Sancta Sophia was his greatest legacy in stone. Its architect-engineers, Anthemius of Tralles and Isidorus of Miletus, brought to the complex job training in mathematics, physics, and engineering. The weight of the tall but shallow dome they devised, 160 feet high and 101 feet wide, is carried by a complex system of four great arches that rest on semi-domes that in turn rest on smaller semi-domes and arcades. The main dome is daringly perforated by 40 windows at its base, so that like the heavens this huge inverted bowl appears to rest on almost nothing.

With the fall of Constantinople to the Turks in 1453, Justinian's church became a mosque and was renamed Hagia Sophia. A quartet of minarets were added around it. Its Christian mosaics were plastered over, not to be uncovered until the 1930s, when the secular government of Kemal Atatürk converted the mosque into the museum it remains today. But no surface alterations could reduce the power of the mighty space itself.

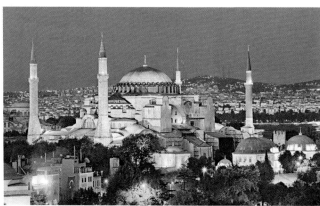

IL DUOMO

FLORENCE, ITALY / 1296 TO 1436

WHEN PLANS FOR THE CATHEDRAL of Santa Maria del Fiore were drawn up in the late 13th century, they included a great dome, larger than anything attempted since antiquity. Too bad no one knew how to build such a thing. The knowledge that had enabled the Romans to construct a hemispheric marvel like the Pantheon had disappeared with their empire. Though work went ahead on the church, more than a century later there was still no progress on the dome. So in 1418 a competition was announced for anyone who could offer a workable design, including a plan for how to support the dome while it was under construction.

The man who would do all this was a Florentine goldsmith, clockmaker, and architect, Filippo Brunelleschi. His ingenious solution to the problem of Il Duomo, which opened the way to the reappearance of great domes all around Europe, makes him one of the most important figures in the history of engineering. He proposed a double shell—a more shallow interior dome enclosed beneath a taller exterior

that would have enough vertical thrust to sustain the weight of a lantern tower on top. To contain the sideways forces that can cause a dome to burst apart under its own weight, he designed a sandstone "chain"—more like a circular railway track of sandstone rails and ties—to be embedded in the dome at three levels and hold it tight like the hoops of a barrel.

Instead of building a dense wooden framework to support the dome as it ascended, Brunelleschi had masons lay its brickwork in ever smaller circles as the walls rose. Because they let the mortar of each circle set before embarking on the next, the dome, in effect, held itself in place. He even invented a complicated ox-driven hoisting machine to lift the heavy building blocks. At its completion in 1436, Il Duomo was not only one of the grandest churches in Europe but a model that pointed the way out of the Middle Ages and into the Renaissance.

THE ARCHITECT-ENGINEER
BRUNELLESCHI

By the time Filippo Brunelleschi began work on Il Duomo in 1420, he was 43 years old and had already impressed Florence repeatedly. First there was his entry—unsuccessful but widely admired—in a 1401 competition to design biblical scenes on bronze panels for the doors of the medieval baptistery next to the cathedral. Twelve years later he developed one of the most revolutionary tools of Western painting, the system of linear perspective that allows an artist to create a persuasive illusion of three-dimensional space on a flat surface. And though no one today knows just when or even whether he received architectural training, his designs for some aristocratic Florentine family chapels and for the city's foundling hospital now rank among the seminal works of the Italian Renaissance.

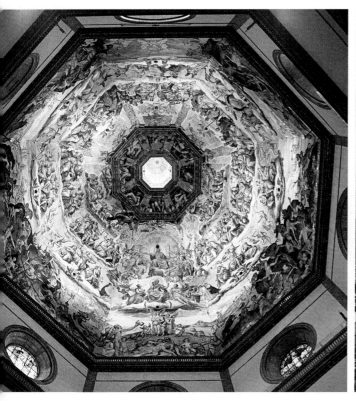

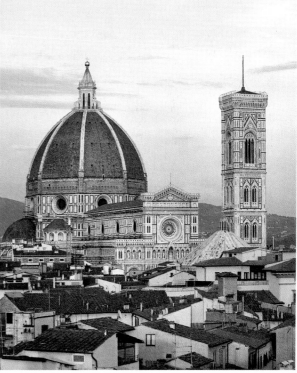

7 | ROADWAYS

Though they may not be among the largest or tallest structures, they can be some of the highest and most dauntingly difficult to build. And certainly among the most essential—the networks that link up the world on dry land.

APPIAN WAY

ROME TO BRINDISI, ITALY / FOURTH CENTURY B.C.

ROME BECAME AN EMPIRE THROUGH the military prowess of its soldiers and generals. But it remained one in good measure because of its roads. Earlier civilizations had built fine roadways, including the Persians and Etruscans, but nothing like Rome's vast transcontinental network of hard surfaced routes measuring over 50,000 miles, ever growing as the empire pushed out its boundaries until it stretched from Hadrian's Wall in Britain to the Sahara, from Spain and West Africa to the Fertile Crescent. In the ancient world it was almost literally true: "All roads lead to Rome."

These roads weren't built merely to accommodate armies, though they could when the need arose, but to speed the movements of tax collectors, administrators, and merchants, all the civilian travelers who made the empire hum.

One of the earliest and greatest of Roman roads was the Via Appia, the Appian Way. About 360 miles long at its completion, it was begun in 312 B.C. by Appius Claudius Caecus. He was a Roman censor, the official charged not only with conducting the census but also overseeing public works. He built it first from Rome southeast to the site of ancient Capua. Not long after, it was extended to Brindisi, a port city on the Adriatic from where ships set out for Greece, Egypt, and the Levant. Tombs and monuments stood along some stretches, as well as cylindrical milestone markers announcing the distance to major towns.

The Roman engineers took great care with the construction of their roads. The best of them, like the Appian Way, were typically three to eight feet thick, built in several layers: first stone slabs laid on excavated ground, then broken stones mixed with mortar, and then concrete. The surface, made of snugly laid basalt pavers, was crested in the middle to shed water. No wonder some parts of the Appian Way can still carry traffic today.

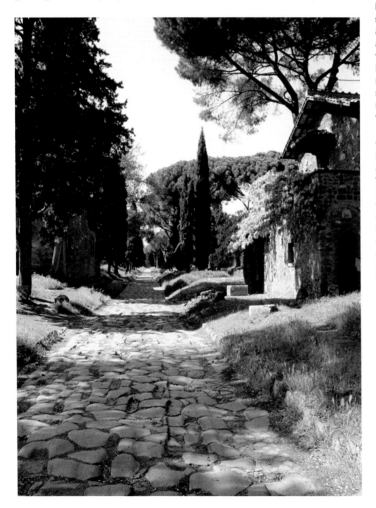

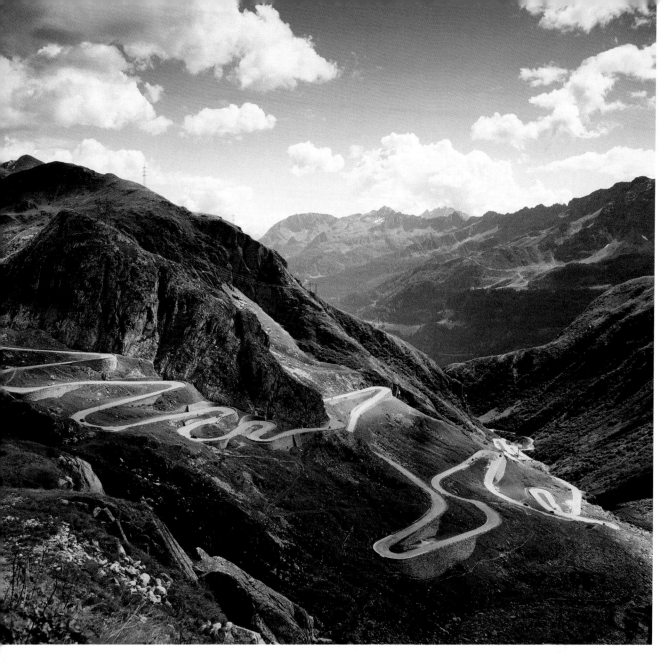

ST. GOTTHARD PASS ROAD

AIROLO TO GÖSCHENEN, SWITZERLAND / 13TH CENTURY; 1820 TO 1830

FOR ALL THAT THEY PRIDED THEMSELVES AS road builders, even the Romans balked at traversing one of the most treacherous Alpine passes on the northern frontier of the Italian peninsula. The rushing waters of what's now called the Reuss River were too difficult to ford, the gorge it roared through too steep. Not until the 13th century was a mule track worked through it, one that took its name from St. Gotthard, an 11th-century bishop of Hildesheim and patron saint of the deadly passes. That first Gotthard road also boasted the Teufelsbrücke—the Devil's Bridge, supposedly built by the Prince of Darkness himself, who demanded as his price the soul of the first person to cross. Legend has it he was thwarted.

Even with a roadway, the difficulties of the route were such that within two centuries the Gotthard Pass was in eclipse. A modern road was arduously completed in the 19th century, making the pass available as a stagecoach route, however strenuous. In 1881 a rail tunnel was also completed 3,000 feet below ground, at the cost of almost 200 lives. A modern highway tunnel opened in 1980, and a new rail tunnel, at 35 miles the longest in the world, is scheduled for completion in 2017. Drivers eager to take in the spectacular views—or to avoid sluggish tunnel traffic—still prefer the open road, even at the price of enduring its hair-raising, hairpin turns. Or maybe that's what they like about it.

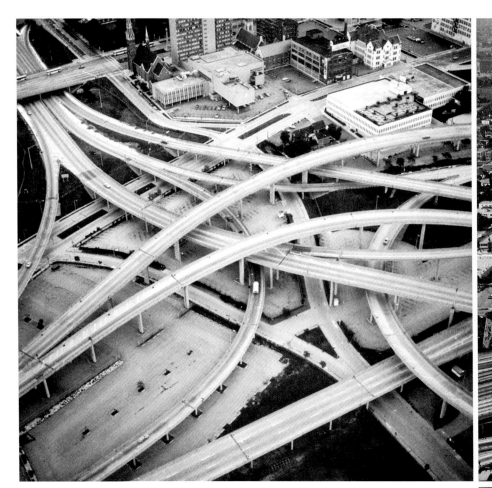

INTERSTATE HIGHWAY SYSTEM
THROUGHOUT THE U.S. / 1956 TO PRESENT

IT'S BEEN CALLED "THE LARGEST public-works program since the pyramids," a $129 billion network of highways stretching from coast to coast and from Canada to Mexico. With more than 47,000 miles of straightaways, overpasses, and banking ramps, it permits the kind of high-speed overland travel—when its routes aren't hopelessly clogged—that seems to be what the automobile was invented for. It's also the one historic feat of engineering that virtually every American has experienced firsthand.

To build it required a multi-decade time frame rivaling the great cathedrals. Though a less ambitious national highway network was in place by the 1920s, it was soon outstripped by the rising ownership of automobiles. With Franklin D. Roosevelt as a major advocate, studies in the 1930s and '40s envisioned a modern system of limited-access, high-speed, multilane highways.

But only under Dwight D. Eisenhower did it get under way. As a young lieutenant colonel in 1919, Eisenhower had joined a military convoy sent to determine how long it would take to move troops and equipment from Washington, D.C., to San Francisco. With half the distance served only by dirt roads, the answer had been 62 days. As Supreme Allied Commander during World War II, Eisenhower had been impressed by how the modern German highway system allowed the quick deployment of forces.

After disagreement over such things as how the system would be financed—mostly by a new federal gasoline tax—and whether states could afford the standardized construction requirements, the interstate was signed into law on June 29, 1956. Though it was declared complete 36 years later, it keeps on growing. So long as there are people and automobiles, it always will.

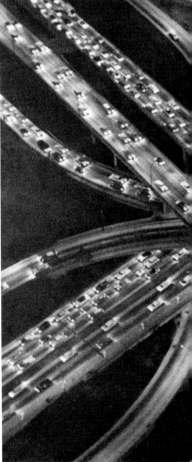

ROAD SHOW
Photos from the 1960s of highway interchanges. Above, Milwaukee and Los Angeles; right, Los Angeles and Seattle.

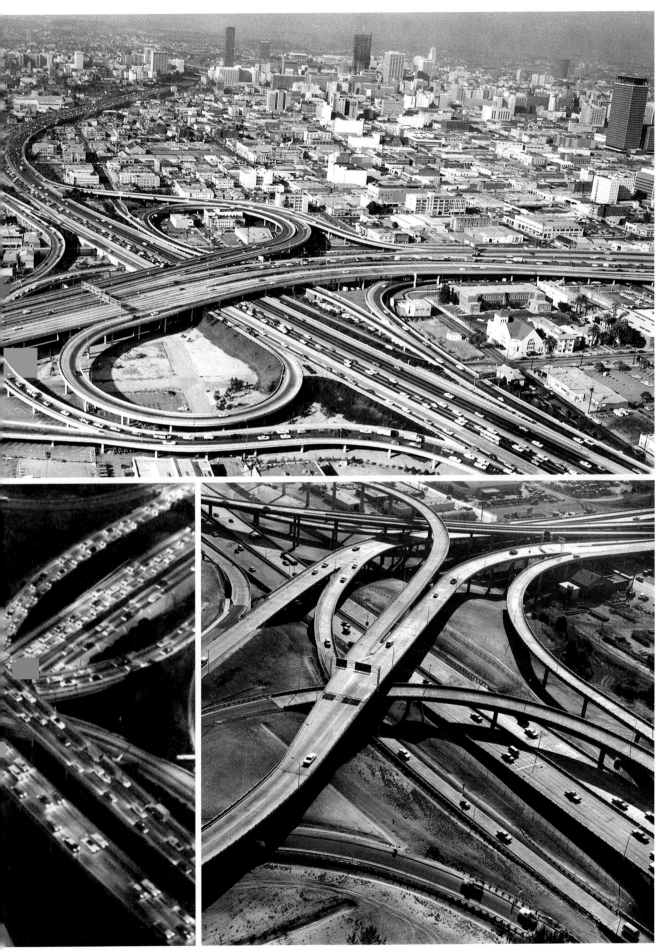

53

MILLAU VIADUCT

GORGES DU TARN, FRANCE / 1993 TO 2004

FOR THE BEST PROOF OF THE continuing appeal of the idea that the shortest distance between two points is a straight line—no matter what lengths are required to draw it—go to the Gorges du Tarn in southern France. Along the highway from Paris to Montpellier, across a 1.5-mile-wide gorge between two plateaus, you'll find the Millau Viaduct, the world's tallest roadway. The work of the French engineer Michel Virlogeux and Foster + Partners, the British architectural firm of Norman Foster, its highest mast reaches an astonishing 1,125 feet, outstripping the Eiffel Tower. Though far beneath it the river Tarn comprises one strand of the wide territory it crosses, the Millau is best thought of not as a bridge but as a long and spectacularly elevated road, the very highest of highways.

For each of its seven piers, workers excavated four deep foundation pits. Then they poured concrete into self-climbing form-work—molds that can rise as the work in progress rises—allowing the piers to ascend more than 13 feet every three days. To minimize the danger of working at great height, 96 percent of the deck construction was completed at ground level. Its modular beam boxes were assembled at factories, then shipped to the site. To surface the roadbed, workers shot-blasted one-millimeter steel bearings over the steel framework to remove all traces of rust before applying a bonding chemical and a thin layer of asphalt. All parts of the bridge are also equipped with a multitude of sensors and measuring instruments. Those were installed to monitor corrosion and structural fatigue, and to detect any movement of the vast but strangely delicate roadway, a steel behemoth that from a distance has the lightness of spun sugar.

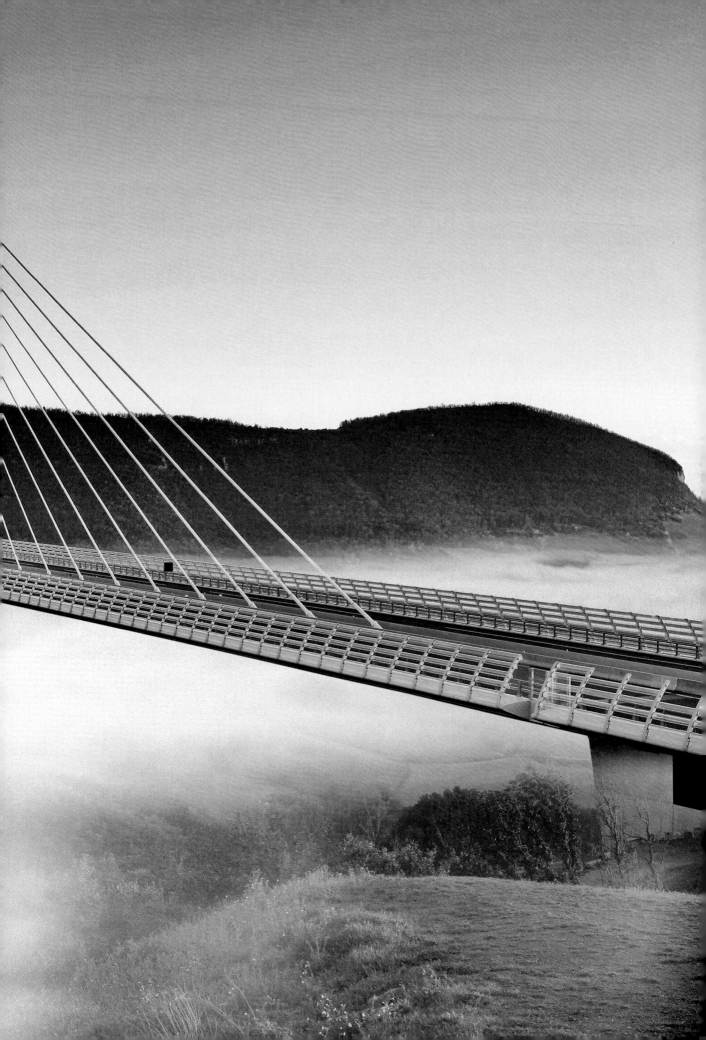

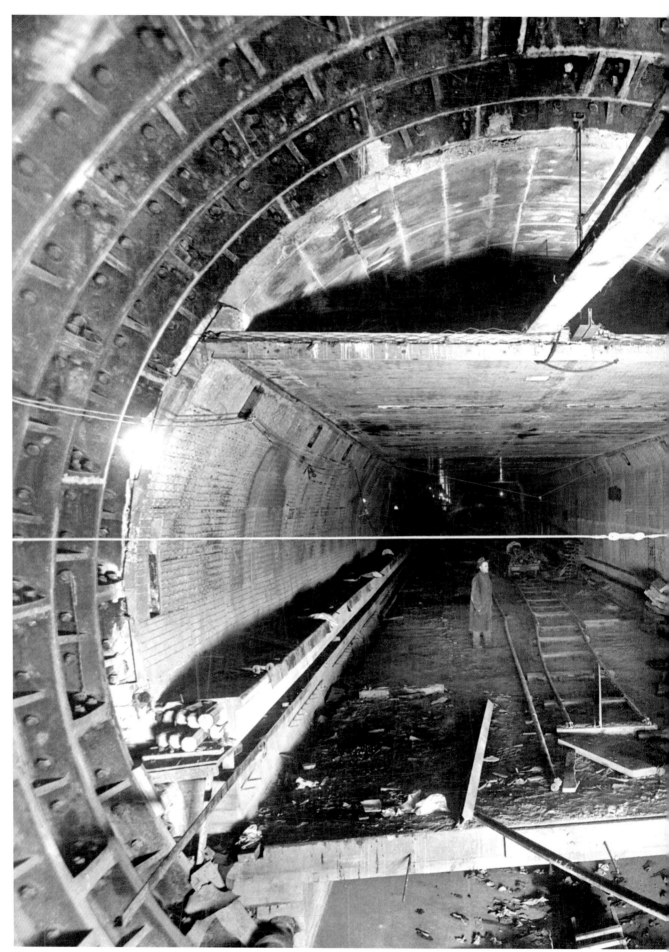

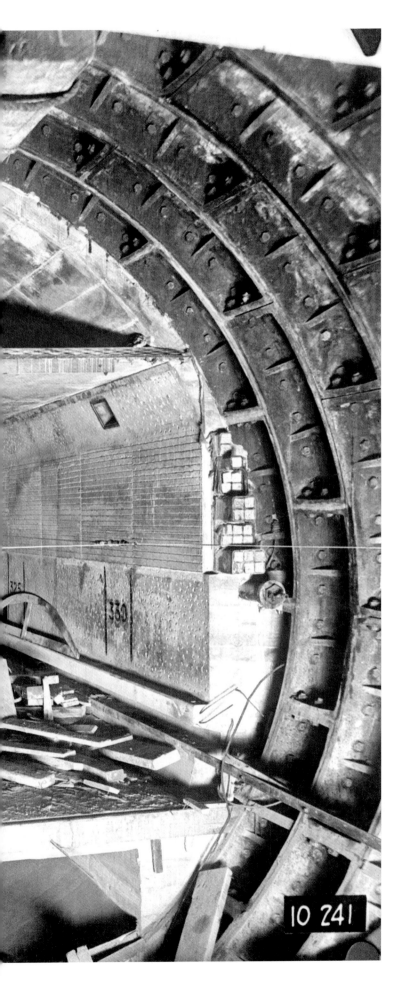

8 | TUNNELS

What happens when an irresistible force meets an immovable object? If the force is the human urge to go forward and the object a mere mountain or riverbed, what happens is a tunnel.

IN GENERAL, THERE ARE THREE KINDS OF tunnels: those that pass through mountains, those that descend under rivers—or even seabeds, like the Chunnel that links Britain and France by rail beneath the English Channel— and those cut beneath cities for subway lines. Even ancient civilizations knew how to dig them. In the 22nd century B.C. Babylonians built a 3,000-foot brick-lined passage under the Euphrates River to connect their royal palace with the temple. The Greeks and Romans dug tunnels to serve their water-supply systems. And 17th-century French engineers produced numerous tunnels along canal routes. But tunnel construction did not get seriously under way until the 19th century, and then largely because of the spread of railways, which had to cross mountains in relatively straight lines, even if that meant going right through them.

The first significant mountain tunnel was the Mont Cenis. A railway passage of 8.5 miles cut through the Alps between Italy and France, it was begun in 1857 and finished 14 arduous years later. It was on this project that the French engineer Germain Sommeiller pioneered the

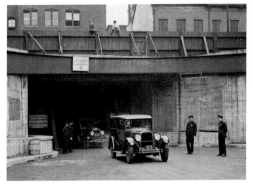

WORK IN PROGRESS Left, the Holland Tunnel under construction in 1925. Above, cars enter Manhattan on opening day.

THROUGH THE ALPS
A worker stands before "Heidi," a drilling machine used to dig the forthcoming Gotthard Base Tunnel in Switzerland.

use of both drill carriages mounted on railway cars and the compressed-air ram—his own invention—to shatter bedrock. He was also the first to employ another recent invention, dynamite, as a rock splitter.

The earliest American railway tunnel, just 901 feet, was completed in 1833 as part of the Allegheny Portage Railroad, a short-lived operation that transported river barges over the Allegheny Mountains on railway cars. But by 1855 a second and much more ambitious project got under way. The 4.75-mile Hoosac Tunnel through the Berkshire Mountains of Massachusetts would take 24 years to complete. Because the rock was too hard for hand drills or early power saws, workers on the Hoosac made extensive use of compressed-air power drills, prototype versions of modern rock drills and jackhammers.

The earliest major underwater passage was London's 1,300-foot Thames Tunnel. Begun in 1825 and completed in 1843, it was the work of Sir Marc Isambard Brunel, a French-born British naval officer and father of the celebrated engineer Isambard Kingdom Brunel. But it was the elder Brunel who solved the problem that for centuries had frustrated all attempts to dig under riverbeds: how to keep mud and water from flooding the tunnel during construction. His answer was a giant rectangular iron casing, later called a shield, that could be pushed along by means of screw jacks. Weighing 120 tons, it contained 36 compartments with shutter openings that could be operated individually, allowing the miners inside to dig out the clay ahead of them.

Another British engineer, James Henry Greathead, used an improved version of Brunel's machine to complete the Tower Subway under the Thames in 1869. Where Brunel's shield was right-angled, Greathead's was round. And as the massive machine pushed forward, it allowed workers to line the tunnel behind it with iron rings. Modern descendants of those 19th-century shields, now made from steel and using hydraulic screws, are still important tools of hard-rock excavation today.

The arrival of automobiles in the 20th century made tunnels even more essential. The first built to serve them was the Holland, completed in 1927 to link Manhattan and New Jersey beneath the Hudson River. It was named for Clifford M. Holland, the engineer who designed it and who solved a very 20th-century problem—car exhaust. To keep the tunnel from filling with noxious fumes, he constructed immense ventilator shafts at each end.

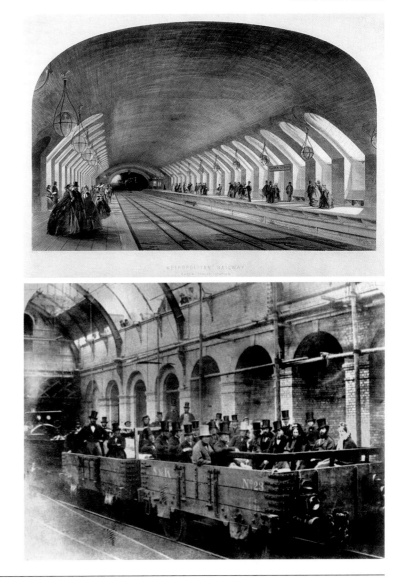

59

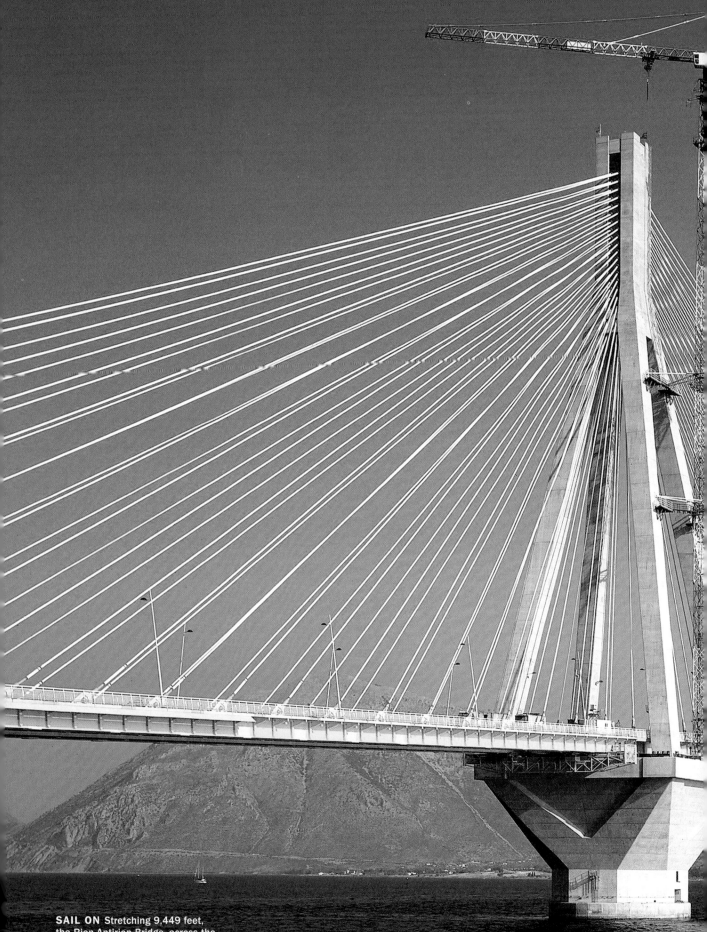

SAIL ON Stretching 9,449 feet, the Rion-Antirion Bridge, across the Gulf of Corinth in Greece, is the world's longest cable-stayed span.

9 | JUST ADD WATER

Water has always provided some of the greatest engineering challenges and opportunities—crossing it via bridges, moving it down aqueducts, extending its reach with canals, and harnessing its power with giant dams.

BRIDGES

WE ALL KNOW THAT BRIDGES are essential sometimes to the movement of cars, trains, and people. The impassioned words of Hart Crane's "To Brooklyn Bridge" make you realize they can move poets too. ("How could mere toil align thy choiring strings!") Something about bridges is inspirational. Of all the products of the built environment, they may be the ones that best demonstrate how beautiful pure engineering can be.

Bridges have existed for as long as there have been bodies of water and people who needed to cross them. But the modern era of bridge building could be said to have started in Britain in the early years of the Industrial Revolution. Iron Bridge, which crosses the River Severn in Shropshire, was the first cast-iron span, the first to forgo wood and stone as its materials. Opened in 1781, it opened an era of ever more elegant and slender arched bridges, in both cast iron and the more malleable wrought iron.

By the 19th century, bridge designers like Thomas Telford were making a name for themselves. His Menai Suspension Bridge in Wales, completed in 1826, was the world's first modern suspension bridge, one in which the deck is hung from

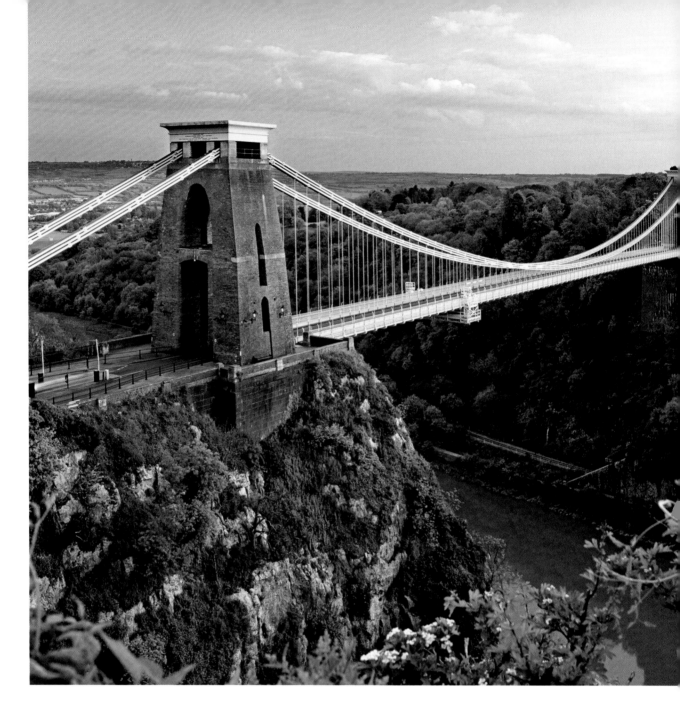

cables between towers. Isambard Kingdom Brunel, the Renaissance man of 19th-century British engineering, who designed railways, steamships, and tunnels, also produced increasingly imaginative bridges. His Royal Albert Bridge at Saltash, with its bounding wrought-iron arches, was even "signed" after his death with plaques reading "I.K. Brunel, Engineer, 1859."

So the traditions of modern bridge building were well developed when the prominent German-American engineer John A. Roebling began planning his masterpiece, the Brooklyn Bridge, the first to use steel-wire suspension cables

instead of iron. With its massive stone masonry towers—for years the tallest structures in New York City—and its 1,595-foot span that would make it the world's longest suspension bridge until 1903, it was meant from the start to be the awesome thing that sent Hart Crane into rhapsodies. But Roebling would not live even to see construction begin in 1870. He died the previous year from tetanus, the result of a foot injury he suffered while surveying the site, leaving his son Washington to see the project to completion in 1883.

In the 20th century the U.S. continued to be the place where the

most dramatic suspension bridges were built. The title of world's longest passed after two decades from the Brooklyn Bridge to the nearby Williamsburg Bridge, which in 1924 handed it briefly to Bear Mountain Bridge a few miles north. Two years later the Benjamin Franklin Bridge in Philadelphia gained it, until the Ambassador Bridge, linking Detroit with Windsor, Ontario, assumed it in 1929.

At a length of 3,500 feet, the next title holder, the George Washington Bridge, connecting Manhattan and New Jersey, nearly doubled the Ambassador's 1,850-foot span when it opened

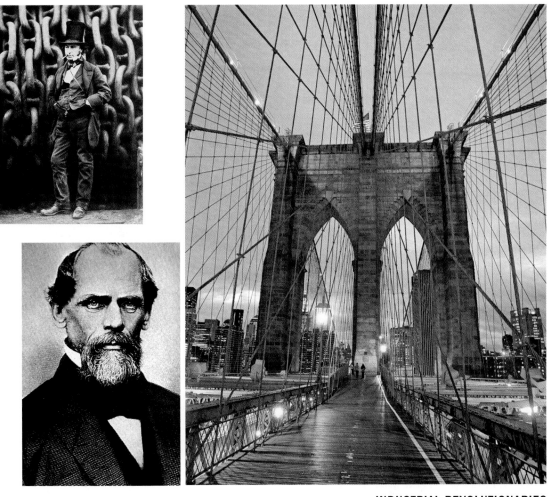

INDUSTRIAL REVOLUTIONARIES
The Clifton Suspension Bridge in Bristol, England (far left), was by the British engineer Isambard Kingdom Brunel (top center). John A. Roebling (above center) designed the Brooklyn Bridge but didn't live to see it started. Its webwork of steel cables (above) became part of its appeal to artists.

in 1931. It also almost had its beautiful steel towers dressed in what was by that time aesthetically retrograde concrete and granite facing. But Depression-era cost cutting made stone too expensive, leaving its lovely erector-set framework, with its intricate crisscross bracing, fully visible. The modernist architectural pioneer Le Corbusier was thrilled. "Here, finally," he wrote, "steel architecture seems to laugh."

And with the next bridge to become the world's longest, it sings. Completed in 1937, the Golden Gate Bridge across San Francisco Bay has a main span of 4,200 feet. A mere statistic. What

makes the bridge unforgettable is its slim elegance, its beautifully picked-out Art Deco detailing, and its refulgent orange-vermilion paint job, which looks lovely in fog and plays vividly against the hills of Marin County.

Ambitious suspension-bridge projects were on hold for most of the 1940s, in part because of World War II, but also because the engineering profession needed time to digest the lessons of the spectacular failure on November 7, 1940, of the Tacoma Narrows Bridge across Puget Sound in Washington State. Within weeks after it was dedicated in July of that

year, the bridge was being called Galloping Gertie because its roadbed was subject to stomach-churning episodes of up, down, and sideways motion. Its final twisting collapse in a steady wind was caught on film and viewed by millions over the years, ensuring that the near disaster (remarkably, no lives were lost) would become one of the most famous bridge mishaps in history. Once the collapse of Gertie was better understood—a major factor was the wind-blocking solid plate girders used to brace the deck—it led to new bracing elements being added to a number of existing American bridges,

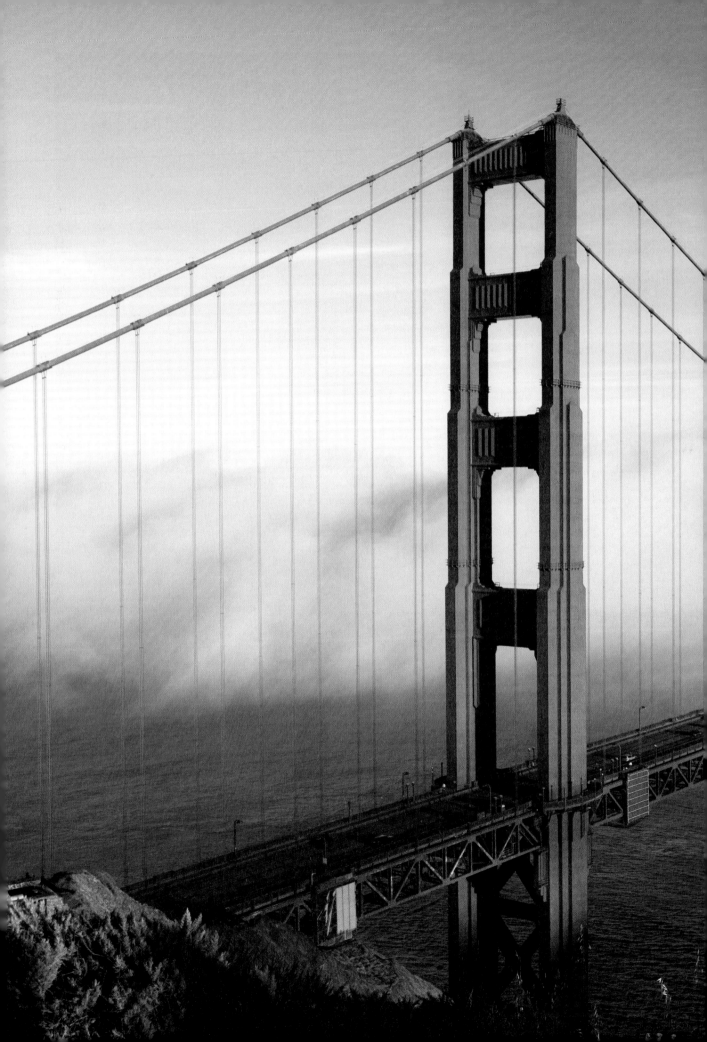

YOU WEAR IT WELL
San Francisco's celebrated fogs merely add to the enchantment of the Golden Gate Bridge. Several designers were responsible for the West Coast masterpiece, including a local architect, Irving Morrow, who added its faceted Art Deco detailing and signature orange-vermilion color.

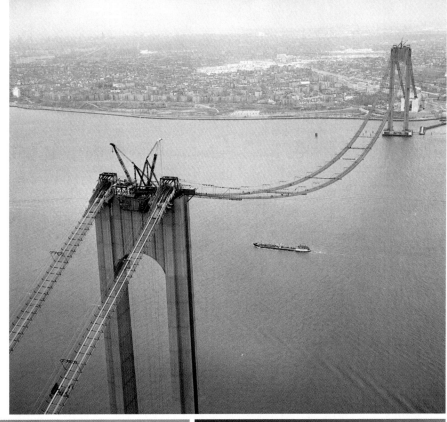

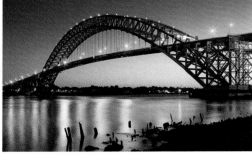

GOOD CONNECTIONS Altogether Ammann worked on six bridges in the New York City area, including (clockwise from left) the George Washington, the Verrazano-Narrows, and the Bayonne.

THE DESIGNER
OTHMAR AMMANN

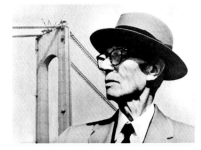

One of the greatest bridge designers of the 20th century was Othmar Ammann, a modest Swiss engineer who arrived in the U.S. in 1904. Eight years later he was working for the famed Austrian-American engineer Gustav Lindenthal, who had long dreamed of a massive suspension bridge across the Hudson River to link Manhattan and New Jersey.

But Ammann thought Lindenthal's vision was too grand. He persuaded the newly formed Port Authority of New York and New Jersey to adopt a more modest plan that would still produce the world's longest suspension bridge, dedicated in 1931 as the George Washington. Remarkably, in those same years Ammann also designed and saw to completion the world's longest arched span, the Bayonne Bridge, between New Jersey and Staten Island. His final project was another record setter, the Verrazano-Narrows Bridge, completed in 1964, just a year before his death.

HIGH STRUNG
The Alamillo Bridge in Seville, Spain, by Santiago Calatrava, is a cantilever-spar cable-stayed bridge built for the city's Expo 92 of that year.

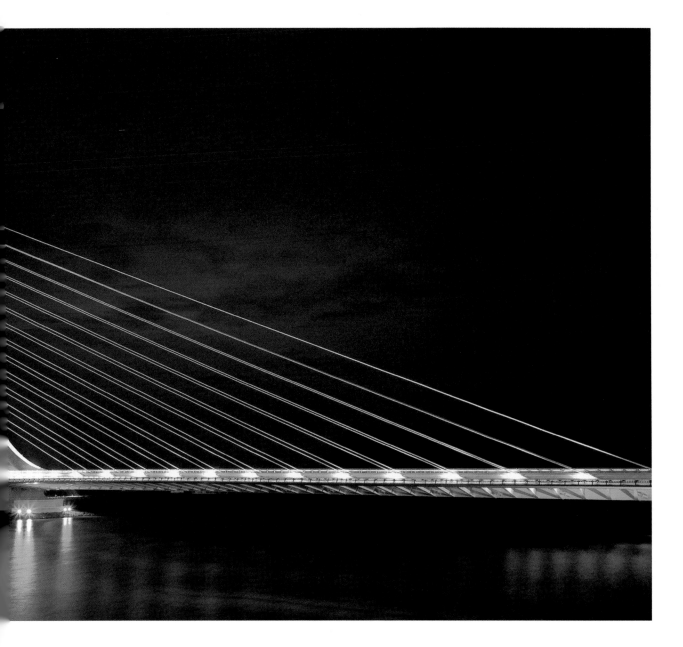

including the Bronx-Whitestone and the Golden Gate.

The last American suspension bridge to qualify as world's longest was the Verrazano-Narrows Bridge, connecting Brooklyn with Staten Island, New York. Completed in 1964, its 4,260-foot span made it necessary for its two towers to be more than an inch farther apart at their tops than their bases to account for the curvature of the earth. In more recent decades the biggest bridges have been built in Europe and Asia. Since 1998 the longest suspension bridge has been the

Akashi-Kaikyō near Kobe, Japan, a stunning 6,532 feet long.

The suspension bridge has also made room for more cable-stayed bridges, a centuries-old design that has emerged as a 21st-century favorite. Instead of relying on the curving lateral cables that give suspension bridges their characteristic silhouette, cable-stayed bridges—like the Rion-Antirion, completed across Greece's Gulf of Corinth in 2004—work by suspending their decks from diagonal cables that are attached to the tops or sides of high masts, so that taken together they look

like triangular mainsails. The cable-stay design has been a particular favorite of Santiago Calatrava, the Spanish architect who is also trained as an engineer and has become famous for his many lyrical bridges. Some of Calatrava's most elegant creations have been "single spar" designs, like his Alamillo Bridge in Seville, Spain. Its cables are attached to a single tower that appears to bend backward, so that cables, tower, and deck form an oblique triangle that resembles a sundial—or, better still, a harp. Talk about "choiring strings."

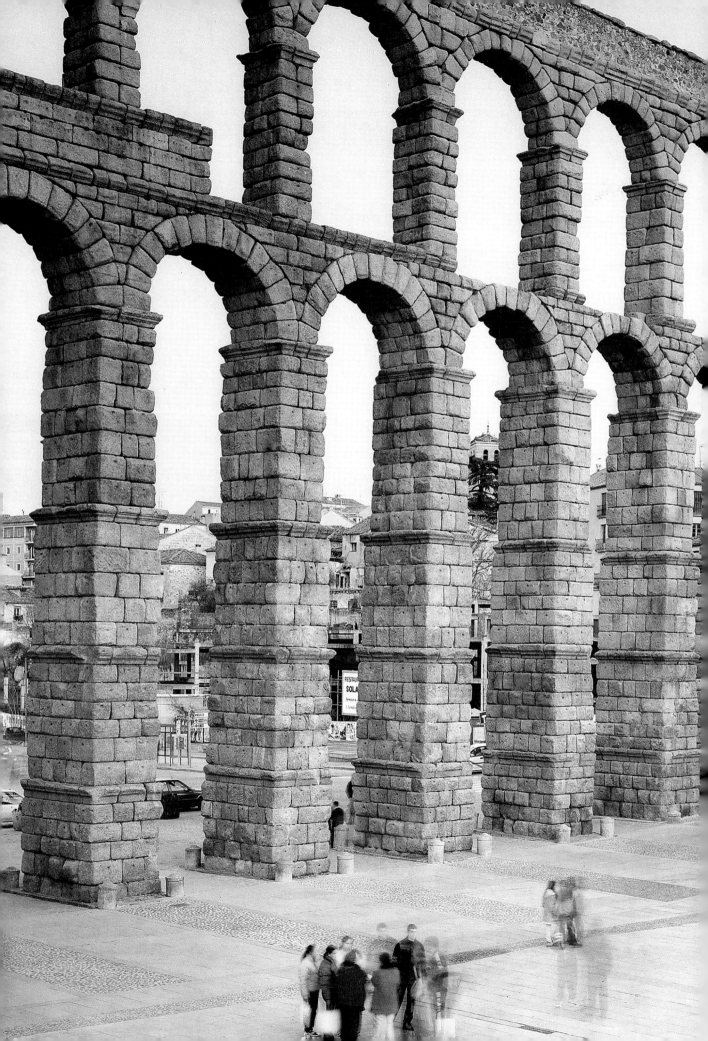

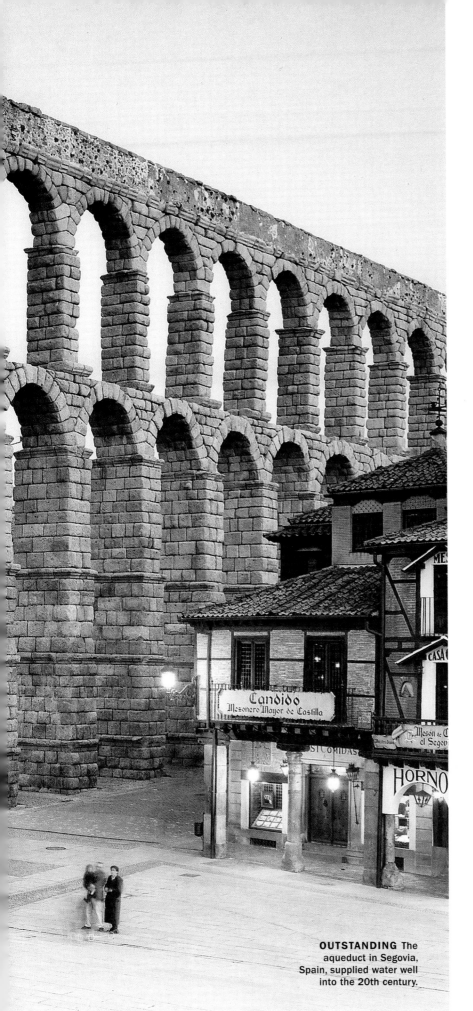

OUTSTANDING The aqueduct in Segovia, Spain, supplied water well into the 20th century.

AQUEDUCTS

JUST AS WITH ROADS, THE ROMANS were not the first to build aqueducts. To cite just two predecessors, the Assyrians and Greeks did it before them. But as with roads, the Romans did it at far greater scale, producing another of the civil-engineering miracles of the ancient world. All across the empire the aqueducts moved their precious cargo gently downhill from mountain sources to provide cities with drinking water, fill the public fountains, serve the private villas of the wealthy, and supply the public baths that were an institution of Roman life. Rome itself had 11 aqueducts, ranging from 10 to 56 miles long and built over a period of five centuries beginning in 312 B.C.

The visible portion of the aqueducts was typically designed as a single, double, or even triple arcade of stone, brick, concrete, or some combination of the three. The water flowed down a channel that ran along the top of the uppermost arcades. But while those coursing arches are the most visually impressive element of the Roman water-delivery system, most of it was below ground, consisting of channels bored through rock or dug through soil. Once the water arrived in the cities it was commonly channeled first into settling tanks to let soil and pebbles drop away. From those it was led to towers that distributed it to smaller tanks, from which it was piped away again to its various final destinations. All in all, a remarkable system. Frontius, who was Roman water commissioner in the first century A.D., was not above boasting about the networks he supervised: "Will anybody compare the idle pyramids, or those other useless though renowned works of the Greeks, with these aqueducts, with these many indispensable structures?"

CANALS

CANALS ARE THE SHORTCUTS OF global shipping, but in the struggle to produce the two most famous—the Suez and the Panama—there were no shortcuts available. The ancient Egyptians were the first to attempt a waterway from the Mediterranean to the Red Sea, by linking the Nile to the Great Bitter Lake, which opens onto the Gulf of Suez. Though the Romans expanded that passage, in the eighth century Arab rulers filled it in. It was Napoleon's occupation of Egypt from 1798 to 1801 that seriously reignited interest in a Suez canal. But for decades the project was discouraged by an imaginary difficulty: the mistaken belief of Napoleon's engineer J.M. Le Père that the Red Sea was 33 feet higher than the Mediterranean, which would have made necessary costly and complicated locks. By 1854, however, with the lay of the land better understood, Ferdinand de Lesseps, a French diplomat and tirelessly enthusiastic canal promoter, had obtained a concession to build a sea-level canal from the viceroy of Egypt. Two years later a second concession gave his newly formed Suez Canal Company the right to operate the canal for 99 years after it opened. By 1859 work was under way.

Construction would take 10 years instead of the six originally envisioned. But because nearly all the digging was through desert sand and soft soil, simple techniques sufficed for early stretches, when peasant laborers pried out the soil with pickaxes and carried it away in baskets. Though dredges and steam shovels were brought in for later stages, not for nothing has the 120-mile Suez been called "a magnificent ditch digger's dream."

And at its opening, not much more than that. The Suez debuted in 1869 as a relatively shallow channel,

THE SHIPS OF THE DESERT That was long a term used to describe camels, but with the opening of the Suez Canal in 1869, actual ships could cross the sands.

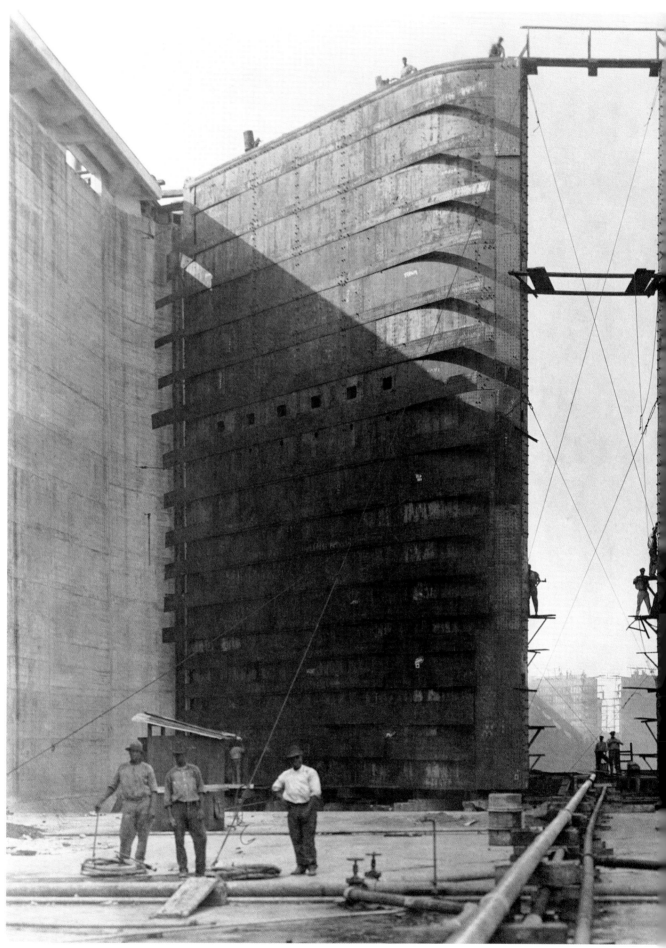

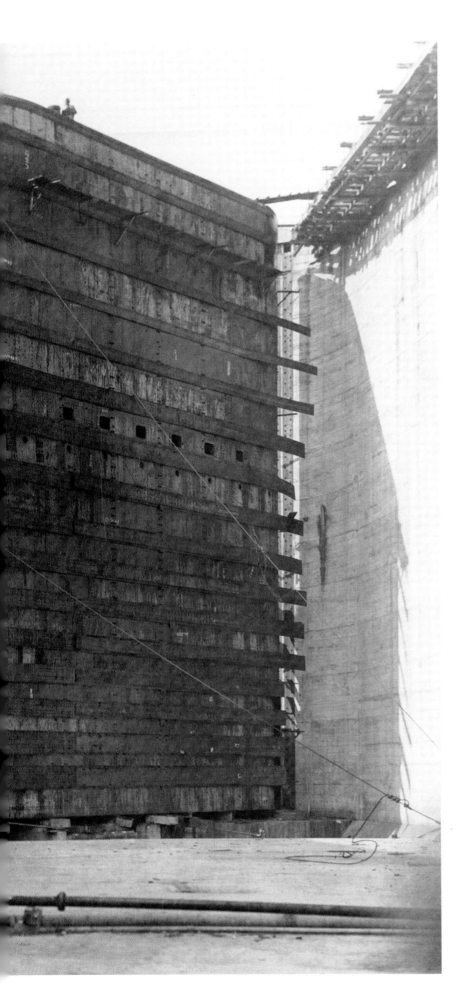

just 26 feet deep and no more than 300 feet wide at the surface, narrowing to just 72 at the bottom. In those meager waters thousands of ships went aground before a series of expansions begun in 1876 made it 40 feet deep and 172 feet wide at its lower edges. Though most of the cargo it handles today—in a voyage that usually takes 15 hours—is crude oil and refined petroleum products, even now it can't handle the largest modern oil tankers when those are fully loaded.

In the 20th century the Suez would become a literal line in the sand, a flashpoint between Egypt and the Western powers. In 1956 Egyptian President Gamal Abdel Nasser nationalized it, setting off an invasion of the Sinai by Israeli forces and of three cities along the canal by France and Britain. But U.S. opposition compelled France and Britain to withdraw by the end of the year and Israel to leave the following March. Egypt closed the canal again during the Arab-Israeli War of 1967. It would not reopen to international shipping until 1975, and even then not to ships from Israel, until the peace treaty signed by that nation with Egypt four years later.

The indefatigable Frenchman de Lesseps would also be the first mover behind the world's next major canal. Almost from the time the Spanish explorer Vasco Núñez de Balboa crossed the Isthmus of Panama to reach the Pacific in 1513, people began to dream of a canal

somewhere across Central America. The narrow isthmus was one obvious option, but so was Nicaragua to the north, where a number of sizable lakes could be incorporated into the route. In 1879, a decade after completion of the Suez, de Lesseps was back in the game, chairing an international conference in Paris to choose the best path for the new canal. He steered that gathering to endorse his preferred route across Panama. But though the French would be the first to attempt a canal, starting in 1881, nine years later their project was bankrupt and largely abandoned, thwarted by the immense difficulties of building in the tropics. Heavy rains had led to landslides that poured soil back into the freshly dug channel. Malaria and yellow fever had claimed perhaps as many as 20,000 lives.

After the French walked away, the U.S. began to take a serious interest in building its own canal. One thing stood in the way. Panama was a province of Colombia, which had permitted a concession to de Lesseps but in 1903 balked at ratifying a canal treaty with Washington. So the American canal required first a U.S.-supported revolt against Colombian rule by the Panamanians. On November 3, 1903, they declared independence. Just three days later the new government, promptly recognized by Washington, signed a treaty approving an American-built and -administered canal.

Preliminary work on the arduous seven-year effort would begin the next year. But it would not be until 1906 that John F. Stevens, the project's new chief engineer, would win the support of President Theodore Roosevelt to forget about the lock-free, sea-level design that had worked at Suez and to commit instead to a canal requiring a large dam, two man-made lakes, and a series of locks to raise and lower vessels en route.

Stevens was right, but building that canal was an immense struggle. As a first step a vast expansion of the Panama Railway was required to move men, material, and equipment and to cart away blasted rock. With doctors now convinced that the malaria and yellow fever that had devastated the French were diseases spread by mosquitoes, medical teams led by Dr. William Gorgas pursued extensive and largely successful mosquito-abatement projects. All the same, some 5,600 workers would die from illness and accidents during the American phase of construction.

Though Stevens enjoyed Roosevelt's full confidence, in 1907, when he felt the project was on a sound footing, he resigned. Roosevelt turned its completion over to the U.S. Army. It would be Lt. Col. George Washington Goethals who headed the effort during now-legendary episodes like the huge Gaillard Cut, an eight-mile gorge that required workers to remove 96 million cubic yards of earth in order to lower its floor to within 40 feet of sea level.

When the 51-mile canal was complete, the U.S. would also own a 50-mile-wide swath of Panama on either side. That Canal Zone would cut the nation in half until it was returned in 1999, the last step in a process begun via a treaty signed 20 years earlier. Like the Suez, the Panama Canal is too small today for the largest tankers and military vessels, but an expansion begun in 2007 and scheduled for completion in 2014 promises to double its capacity.

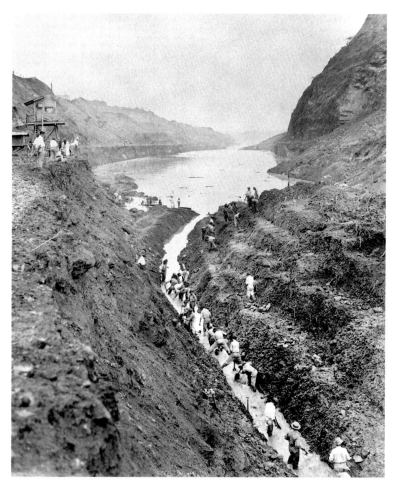

MAKING THE CUT Left, laborers with picks and shovels open the Panama Canal's Gaillard Cut. Right, an aerial view of the canal's Miraflores lock shows its lanes that run in both directions.

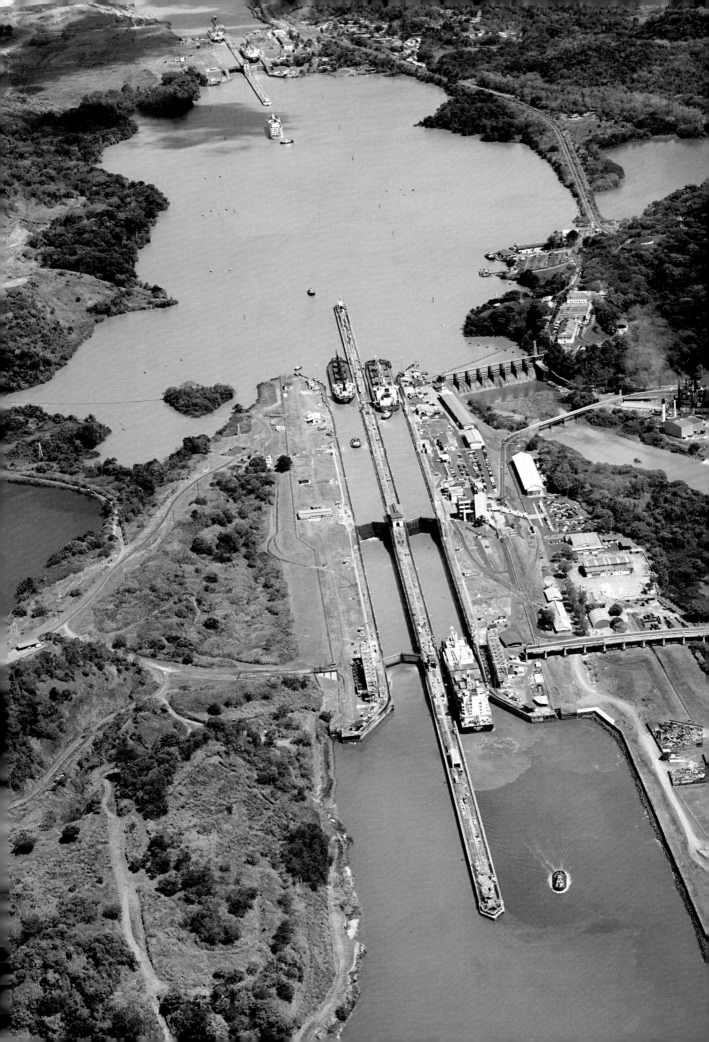

AROUND THE BEND
A panoramic view of the
Hoover Dam shows the four
penstock towers that funnel
water to the generators.

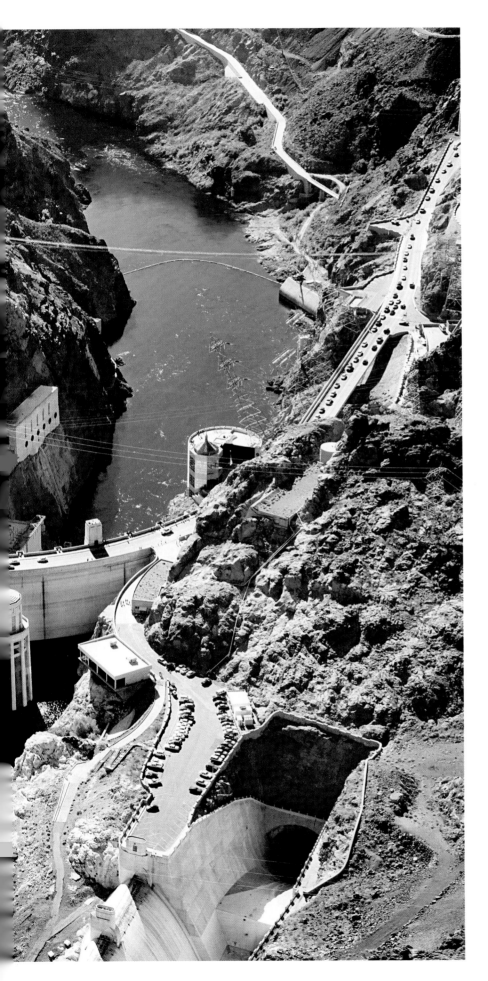

DAMS

NOTHING SAYS POWER QUITE LIKE a hydroelectric dam. In no other structure is the idea of tremendous force, both force held in check and force unleashed, made so tangible. The Hoover Dam, at the time of its completion the largest in the world, is a prime example. It rises 726 feet above the Colorado River at the Arizona-Nevada border, stretching 1,244 feet across the Black Canyon. The artificial reservoir it created, Lake Mead, is the largest in America. At that size, the Hoover is too big to do just one thing, so it's a multitasker, providing flood control, irrigation, and drinking water, as well as electric power for more than 1.3 million people in three states. Named for President Herbert Hoover, who played a role in getting it under way, it was of course one of the costliest and most complex construction projects in American history and a powerful symbol of national resolve. As the former NBC news anchor Tom Brokaw once put it, the Hoover Dam was "our pyramids."

The ambition to tame the Colorado, which began in the 19th century, got a serious push forward in 1902, when Congress passed the Reclamation Act to provide a means for funding irrigation projects in the American West. It led to a series of studies examining ways that the river might be controlled. Several devastating floods in the two decades that followed gave the idea even greater urgency. Asked by Congress to settle on a solution, Arthur P. Davis, director of the Reclamation Service, recommended in 1922 the construction of a massive dam at or near Boulder Canyon. Nine years later, having secured the agreement of six of the seven states the project would affect, the renamed Bureau of Reclamation opened bidding. Because no single American company was large enough to tackle the mammoth work, half a dozen banded together. Using the name Six Companies, they won the contract with a bid of just under $49 million—nearly $600 million in today's dollars and, at the time, the largest government contract ever signed. But with the Depression under way, the

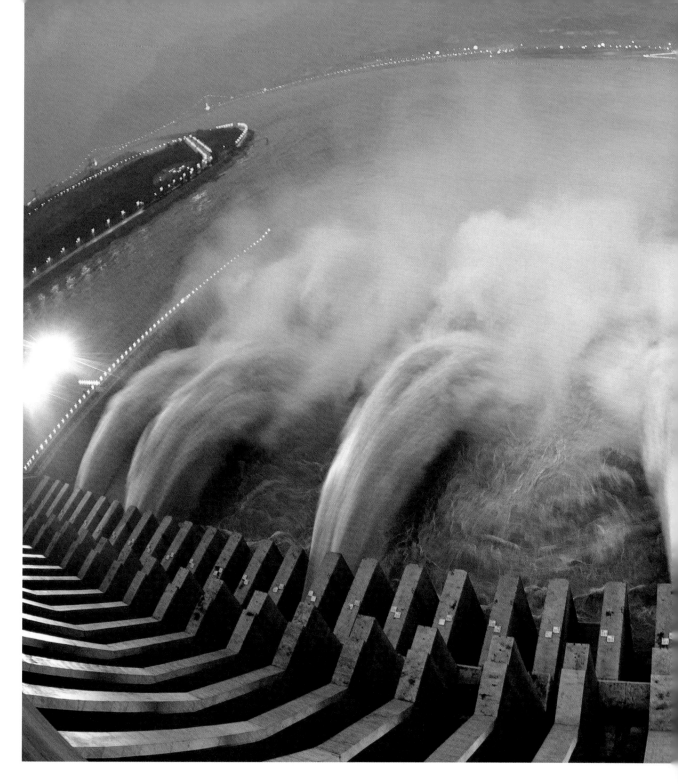

Hoover was not just a dam. It was a stimulus project.

Construction began in 1931 under the supervision of a veteran dam builder named Frank Crowe. The Hoover was designed as a concrete arch-gravity dam. Its convex curve transfers the immense weight of the waters it holds back to the walls of the canyon on either side, effectively making the earth itself part of the support structure. Building it required more than 21,000 workers over the years. One hundred and seven would die in the effort.

To create dry ground on which to build, the Colorado River had first to be pushed out of the way. For that purpose, 50-foot-wide diversion tunnels were dug on either side of the canyon and the river drawn down them. Temporary coffer dams were built next, up- and downstream from the construction site, allowing the enclosed area to be pumped out. Then the real work began. In temperatures that could reach to 120 degrees, men slung from rope harnesses used heavy drills to punch holes in the cliff walls, where explosives would be inserted to blast away the rock face. By 1933 the first concrete was put in place, in a system whereby it was poured into a series of cube cells that were linked tight-

ly together. When it was all done, enough concrete had been used to lay a two-lane highway from New York to San Francisco. Though it's just 45 feet wide at the top, where a highway runs across it, the dam measures 650 feet at its base to hold back the 10 trillion gallons of Lake Mead, which pushes against it with a pressure of up to 45,000 pounds per square foot.

Immense as it is, the Hoover is no longer the largest dam in the world. That distinction has passed to the Three Gorges Dam, on the Yangtze River in China's Hubei province. The Chinese Nationalist leader Sun Yat-sen first proposed a dam

THE BIG SPILL
In July 2012 a torrent
of water was released
at the Three Gorges
Dam after heavy rains
caused flooding in
areas upriver.

in the beautiful Three Gorges region in 1919. Mao Zedong was so anxious to see one built that he offered—it's hard to say how seriously—to step down as chairman of the Communist Party to spearhead the project. Under his rule China was too poor for such a massive undertaking, but when the nation became a rising economic powerhouse in the 1980s, the idea was revived as a way to supply a growing appetite for electrical power. Plans were approved in 1992; the $22.5 billion dam began operating 11 years later.

Though Three Gorges certainly works as a clean-energy power provider, with a combined generating capacity that's the equivalent of 15 nuclear-power plants, in many other ways it has been a deeply problematic project. Unlike the Black Canyon region around the Hoover, the area surrounding Three Gorges was heavily populated. By the time the last of the dam's generators went online in July 2012, more than 1.4 million people had been moved. A 410-mile-long artificial lake created by the dam had also destabilized surrounding cliffs, leading to dozens of deadly landslides. And because that reservoir sits on two major fault lines, there are also fears that the practice of draining it during flood seasons and then refilling it could trigger earthquakes, a problem called reservoir-induced seismicity.

In 2011 the Chinese government acknowledged that while the dam had offered benefits in the areas of flood prevention, power generation, and water use, it had also "caused some urgent problems in terms of environmental protection, the prevention of geological hazards, and the welfare of the relocated communities." However useful Three Gorges may be in satisfying China's growing hydropower needs, it serves as a warning that man-made wonders can be man-made blunders, too.

10 WORLD'S FAIR WONDERS

For many years, universal exhibitions have been incubators of engineering innovation, offering an early look at where the art and science of building might be headed.

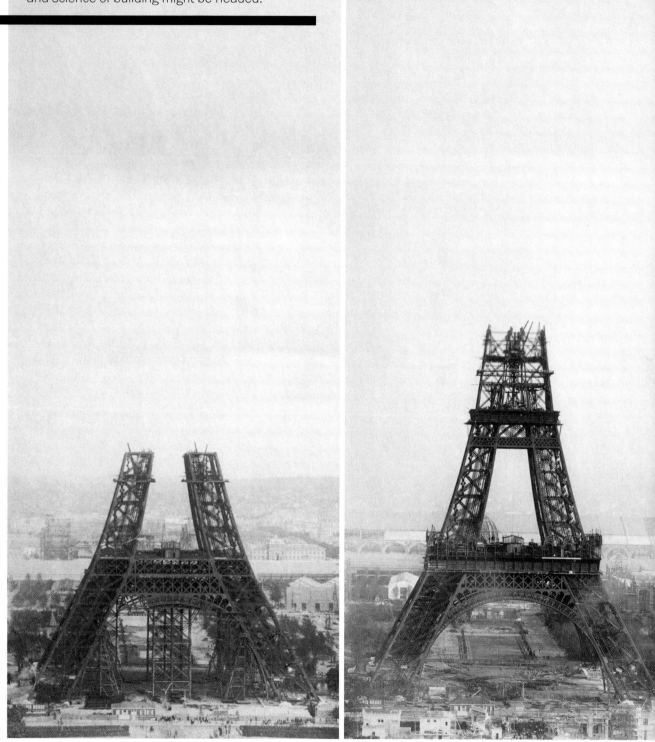

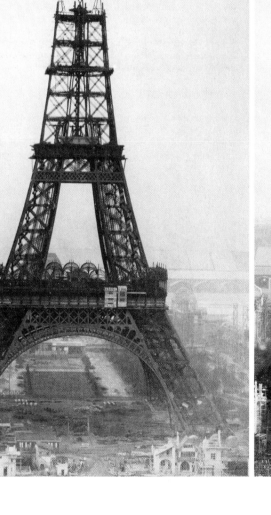
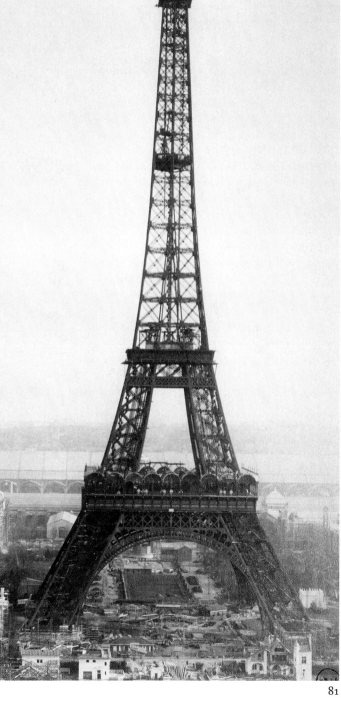

EIFFEL TOWER

PARIS, FRANCE / 1889

THOUGH IT'S IMPOSSIBLE NOW TO IMAGINE PARIS without it, the Eiffel Tower was supposed to be temporary. A monument to the 100th anniversary of the French Revolution, it was built for the Universal Exhibition of 1889 with the intention that it would be demolished after 20 years. But though some influential Parisians hated the tower when it was new, the French kept granting it reprieves until they realized it had become an indispensable symbol of their city.

By the time he embarked on the tower, Gustave Eiffel and the engineering firm he started at the age of 32 were well known for hundreds of structures throughout Europe and beyond, including railway stations, buildings, and especially bridges and viaducts. In 1884 his firm had also designed the internal armature of the Statue of Liberty. To support the thin copper sheets of Frédéric Bartholdi's famous sculpture, two of Eiffel's engineers, Maurice Koechlin and Émile Nouguier, devised a light framework around two much thicker pylons.

That same year the pair began sketching plans for a possible tower for the upcoming Universal Exhibition. Eiffel liked their idea, patented it with them, and promoted it successfully to the exhibition organizers. But just weeks after construction started, a protest appeared in the February 14, 1887, issue of the influential newspaper *Le Temps*. Signed by a number of French cultural luminaries, it denounced the tower as "monstrous... an odious column of bolted metal." Eiffel shot back in an interview that his monument would produce "a great impression of force and beauty."

It took just 22 months to complete the tower, which was assembled from 18,000 prefabricated iron pieces. At 1,000 feet it was the tallest structure in the world, a title it would hold until the Chrysler Building took it away in 1930. And the French reaction? Once they saw it finished, they loved it. And loved him, too—so much that they let it go on carrying his name.

SPACE NEEDLE

SEATTLE, WASHINGTON / 1962

THE SEATTLE WORLD'S Fair of 1962 was designed from the start to be the first fair of the Space Age. It opened on April 21, 1962, just 11 months after President John F. Kennedy had made his famous address before Congress pledging that within a decade the U.S. would put a man on the moon. The fairground pavilions were keyed to the theme of planetary exploration. The Ford Motor Company treated visitors to "An Adventure in Outer Space." The aerospace giant Boeing built a "Spacearium." The cartoon series *The Jetsons* would debut on TV that fall, and it feels right that the Space Needle, the fair's strenuously modern centerpiece, looked like something George Jetson might see every day from the bubble top of his aerocar.

In design the 605-foot Space Needle resembles a flying saucer perched on an aerodynamic tripod, with an elevator shaft running up its center. It was literally first sketched out on a coffee-shop place mat by Edward E. Carlson, a Seattle businessman and chairman of the fair. On a trip to Germany he had been impressed by the Stuttgart Tower, a television-transmission tower, and he wanted an equally dramatic statement for his fair. He imagined something like a tethered balloon. After selling the idea to his fellow planners, he brought it to the architect John Graham, who developed the balloon idea in the direction of its present saucer silhouette and turned it over to his engineers to produce a buildable concept.

To ensure the stability of the precarious-looking structure, 467 truckloads of cement were poured into a steel-braced excavation 30 feet deep and 120 feet across. That produced a foundation weighing almost as much as the 9,550-ton Space Needle itself. Seventy-two bolts, each 30 feet long, attach it to the tower. The restaurant at the top sits on a turntable 94.5 feet wide that makes one full revolution every 47 minutes.

Altogether, it's one very futuristic silhouette. No doubt the Space Needle offers a dated, even campy idea of the future. Yet who can deny that, half a century after its completion, it still somehow oozes tomorrow-ness?

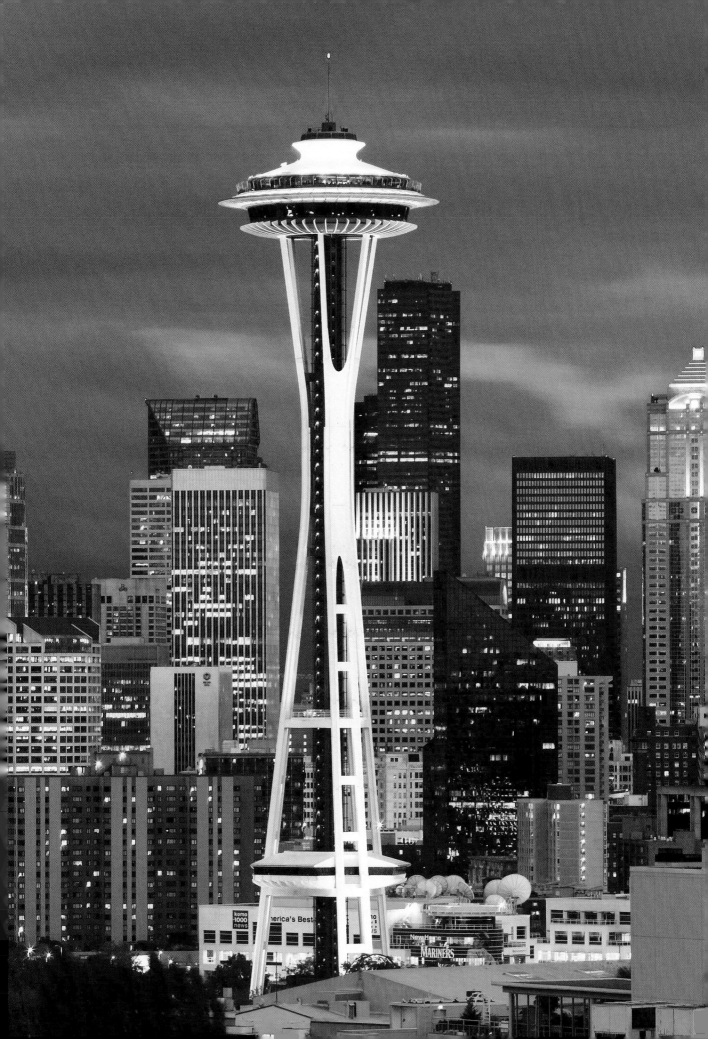

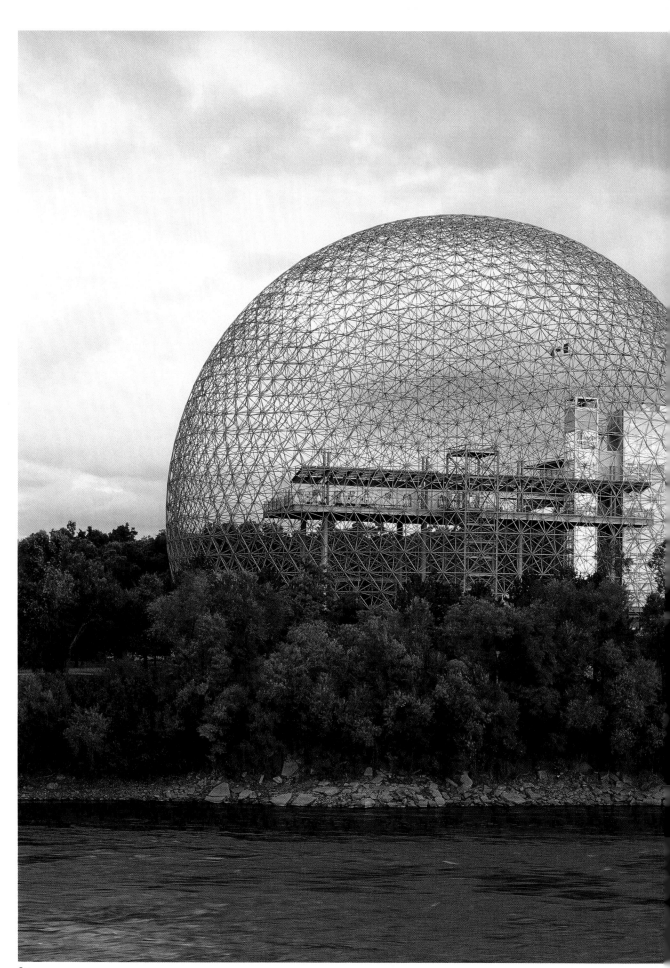

MONTREAL BIOSPHÈRE

MONTREAL, CANADA / 1967

IN THE WHOLE FIELD OF 20TH-CENTURY design, there was no one quite like R. Buckminster Fuller. Engineer, environmentalist, and poster boy for the very idea of visionary, the singular man who coined the term "Spaceship Earth" operated for the most part outside the academic and professional mainstream. Born in 1895 in Milton, Massachusetts, he was twice expelled from Harvard. A failed business venture with his father-in-law and the death of a beloved daughter brought him to a moment of personal despair. He emerged from that episode in the late 1920s determined to devote himself to nothing less than a life of producing innovations for the benefit of humanity. Remarkably, he did. Though few of his conceptual breakthroughs—with one crucial exception, the geodesic dome—were widely adopted in his lifetime, they continue to fascinate and inspire.

Convinced, as he would later put it, that "making the world's available resources serve 100 percent of an exploding population can only be accomplished by a boldly accelerated design revolution," he offered one invention after another. From 1927 to 1929 he developed his hexagonal (later round) prefabricated Dymaxion House. Its windowed aluminum walls suspended from a central mast, it could be air-delivered anywhere.

In 1933 came the three-wheeled Dymaxion Car. Though it held 11 passengers and used half the gas of ordinary cars, it was sidetracked after a highly publicized crash near the entrance to that year's Chicago World's Fair.

In the summer of 1948 Fuller landed at North Carolina's legendary Black Mountain College, a forcing ground of creativity where the faculty boasted original minds like the composer John Cage, the architect Walter Gropius, and the painter Robert Motherwell. It was there he began work on the geodesic dome. With a lightweight framework of triangular connections, the design as he developed and perfected it was an endlessly expandable structure, requiring no interior supports, that can sustain its own weight. Maximum strength, minimum structure—an engineer's dream.

The domes clicked. The U.S. Army used them for military housing. Businesses put them up for factory shells. But they truly entered the collective imagination when a geodesic sphere was chosen to house the U.S. pavilion at Expo '67, that year's world's fair in Montreal. (It now contains the Montreal Biosphère, a museum devoted to educating visitors about the environment.) A transparent globe with an interlocking webwork surface, it still has the power to delight—it's a solid thought balloon.

11 | TOWERS OF STONE

One of the oldest and most powerful motivations behind
the human drive to build is the desire to go higher.
That ancient ambition led in time to one of the most significant
advances in the history of engineering, the skyscraper.

IN THE LAST DECADES OF THE
19th century, construction practices
made a leap forward comparable to
the Gothic revolution of the Middle
Ages. Until then, the walls of most
stone-masonry buildings were
self-supporting. This put practical
limits on how high a building could
go. The lower portions had to be
thick enough to support the weight
of everything above them. But
in the 1880s a new kind of building
emerged. In these the walls were
simply attached like panels to an
underlying steel frame that did
the real work of carrying the
structure's great weight. Buildings
of this kind made their first
appearance in Chicago, a city that
was a natural laboratory for new
ideas in construction. The Great
Fire of 1871 had swept away whole
neighborhoods, and architects

and engineers flocked to Chicago
to rebuild a city that was in some
places a blank slate.

The steel (or, less frequently,
iron) skeleton had its sources in
the "balloon frame," a support
structure that became popular in
19th-century wood construction
after standardized milled lumber
and manufactured nails became
widely available. The steel version
was a variation on the same form,
a three-dimensional grid of inter-
locking piers (verticals) and girders
(horizontals), with exterior walls
applied to that network as wafers of
metal or masonry.

The first of the new steel-framed
constructions, the Home Insurance
Building, was designed by the
architect-engineer William Le
Baron Jenney and completed in
1885. It was small by contemporary

**GOLDEN
TRIANGLE**
The photographer
Alfred Stieglitz,
who featured it in
some of his most
famous pictures,
once said: "The
Flat Iron is to the
United States what
the Parthenon
was to Greece."

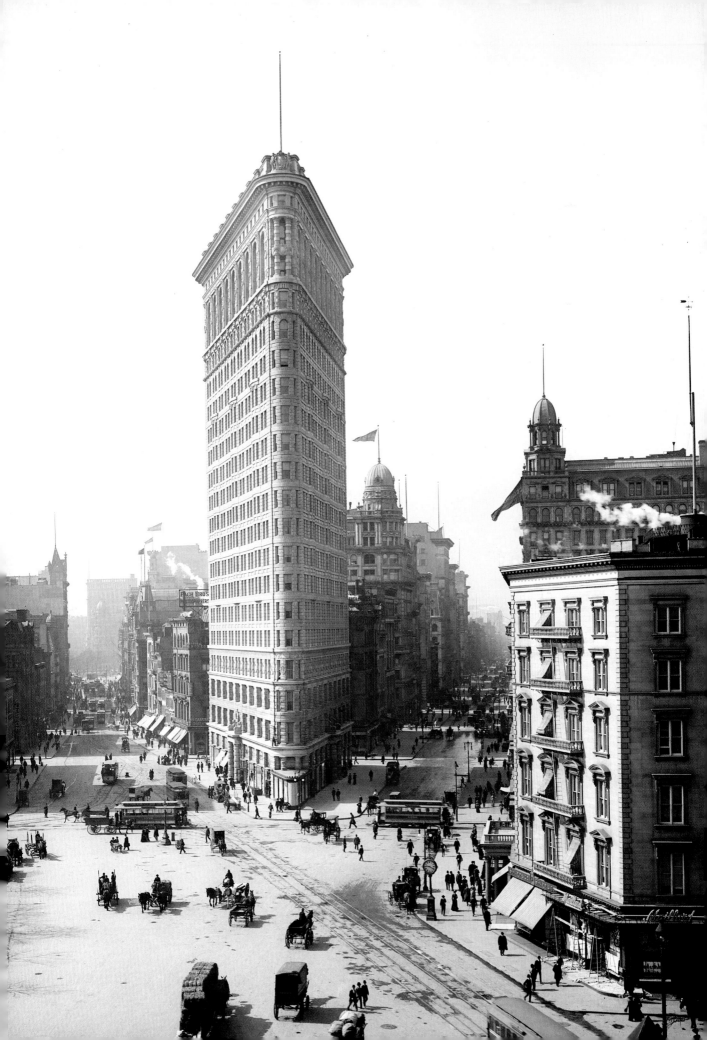

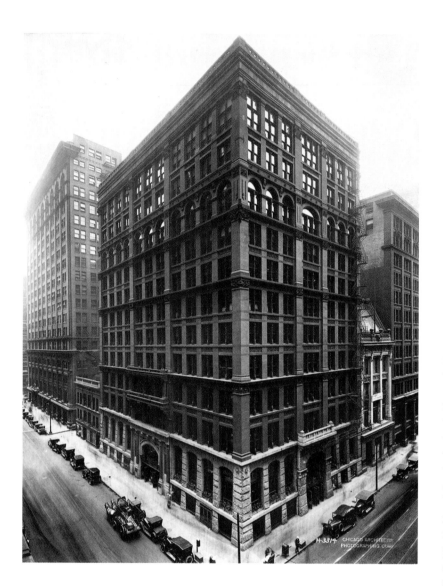

standards, just 138 feet, or 10 stories, though two more were added in 1890. But it represented the initial step in a revolution. City inspectors even stopped work on the building for a while until they could be persuaded that this strange new idea was safe. Once that model was perfected, buildings of 10 stories or more would still occasionally be built with "load-bearing" walls. One was the 17-story brick Monadnock Building, designed by the skyscraper pioneers Daniel Burnham and John Wellborn Root, which went up in Chicago in 1891. But steel frameworks

would quickly become the norm.

Just as engineering and aesthetic advances went hand in hand in the evolution of the great cathedrals, so with the development of skyscrapers. The new altitudes called for a wholesale rethinking of building design. In 1896 the great Chicago architect Louis Sullivan—who had worked briefly for Jenney and would in turn employ the young Frank Lloyd Wright—declared that the chief characteristic of a skyscraper was its height. Therefore, he reasoned, it "must be tall, every inch of it tall...rising in sheer exaltation from bottom to top...without a single

dissenting line." Certainly that was true of his Guaranty Building in Buffalo, New York, from 1895, which stressed its own verticality by tall ranks of windows. Flanked by long masonry piers, they form a palisade of vertical recesses, each culminating in an arched top that gave the entire façade the fluted surface of a Corinthian column. And just as the buttresses of a Gothic cathedral provided the support to permit greatly enlarged windows, the non-load-bearing walls of the new tall buildings could admit broad panels of glass, separated by no more than narrow channels of masonry. Windows with a wide, solid pane flanked by narrower ones became so common in the work of Chicago architects that they were called Chicago windows.

From the perspective of developers, skyscrapers solved the great problem in the economics of urban development. Cities were dense; therefore, real estate was costly. Tall buildings heaped the available acreage into supremely profitable stacks. So from Chicago the gospel of tall buildings spread to other parts of the U.S., to Buffalo, St. Louis, and especially New York City, where the next great advances would take place. Skyscrapers in Manhattan would grow to even greater heights and assume elegant new forms. The slender wedge of Daniel Burnham's Flatiron Building, the first structure to reach and surpass 200 feet, was completed in 1902 on a narrow triangular block

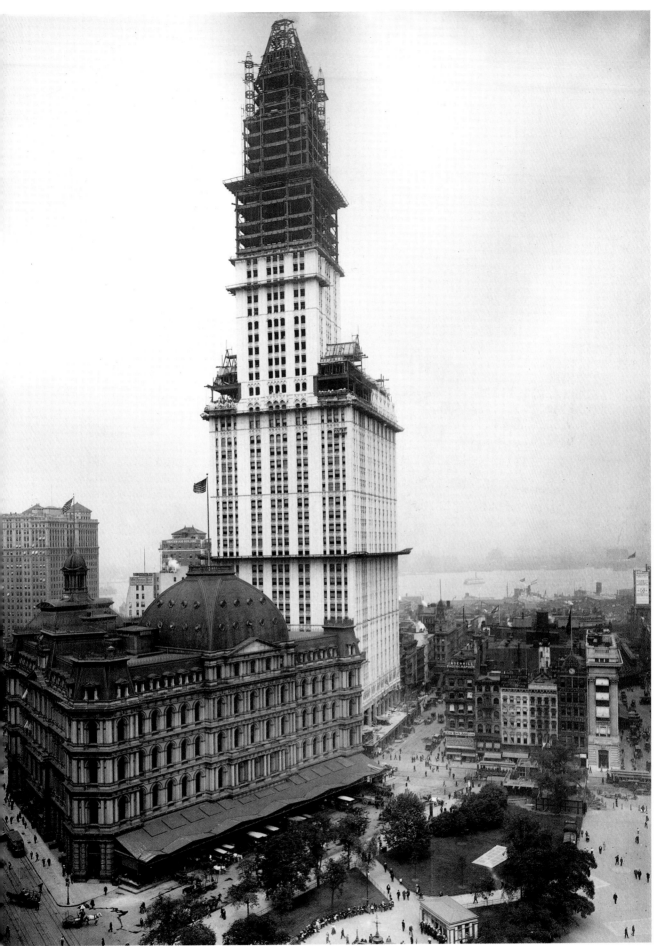

where Broadway sliced across Fifth Avenue. To artist-photographers like Alfred Stieglitz and Edward Steichen it was irresistible, a 22-story prow sailing uptown. As the Brooklyn Bridge had done two decades earlier, the Flatiron proved that modernity had romance.

When it was completed in lower Manhattan in 1913, the 792-foot Woolworth Building was the tallest in the world, with 55 stories, 28 of them forming a white box from which a freestanding white tower climbs. By that year, with buildings going to what were then unimaginable heights, architects were struggling to draw these leaping things back into the traditions of architectural history. So Cass Gilbert—who as late as the 1930s would adapt Greek temple design for the U.S. Supreme Court building—ornamented the Woolworth with all kinds of Gothic detailing, including gargoyles, turrets, and flying buttresses. Inevitably it became known as the Cathedral of Commerce.

The very tall buildings required a new kind of laborer, one willing to operate hundreds of feet above street level. Many of the new "high steel workers" were Native Americans. Members of the Mohawk tribe of upstate New York, they first entered high-altitude work in the 1880s, during the construction of a bridge across the St. Lawrence River onto Mohawk land.

The era of masonry skyscrapers that the Woolworth epitomized culminated in 1930 and '31 with the completion of two of Manhattan's most famous vertical landmarks. The architect William Van Alen deliberately set out to claim for the Chrysler Building the title of world's tallest. This put him into a competition with his ex-partner H. Craig Severance, who had the same

ambition for the project he was designing for 40 Wall Street. When Severance wrongly concluded that Van Alen's building was complete, he topped off his own, only to have Van Alen unexpectedly unveil a 12-story spire atop the Chrysler. It had been secretly constructed in the building's fire shaft, then raised through the roof, crowning the tower at 1,046 feet, more than 100 feet taller than its rival. But just 11 months later the Empire State Building would debut at 1,454 feet, making it the world's tallest skyscraper

until the north tower of the World Trade Center was finished in 1972.

The Chrysler Building and the Empire State were both completed in the first years of the Great Depression. Along with the RCA Building (now the GE Building) at Rockefeller Center, they would be the last significant skyscrapers to rise in New York until after World War II, when a different kind of tall building would appear, in a new idiom of glass and steel that was inspired by European architect-theorists but embraced first in America.

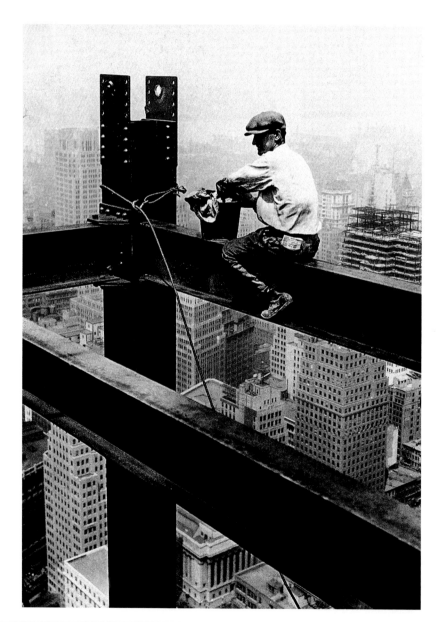

HIGH PLACES During construction of the Empire State Building in 1930, a bolter perches himself on a beam on the 52nd floor. Far right, the Empire State and the Chrysler Building preside over the midtown Manhattan skyline.

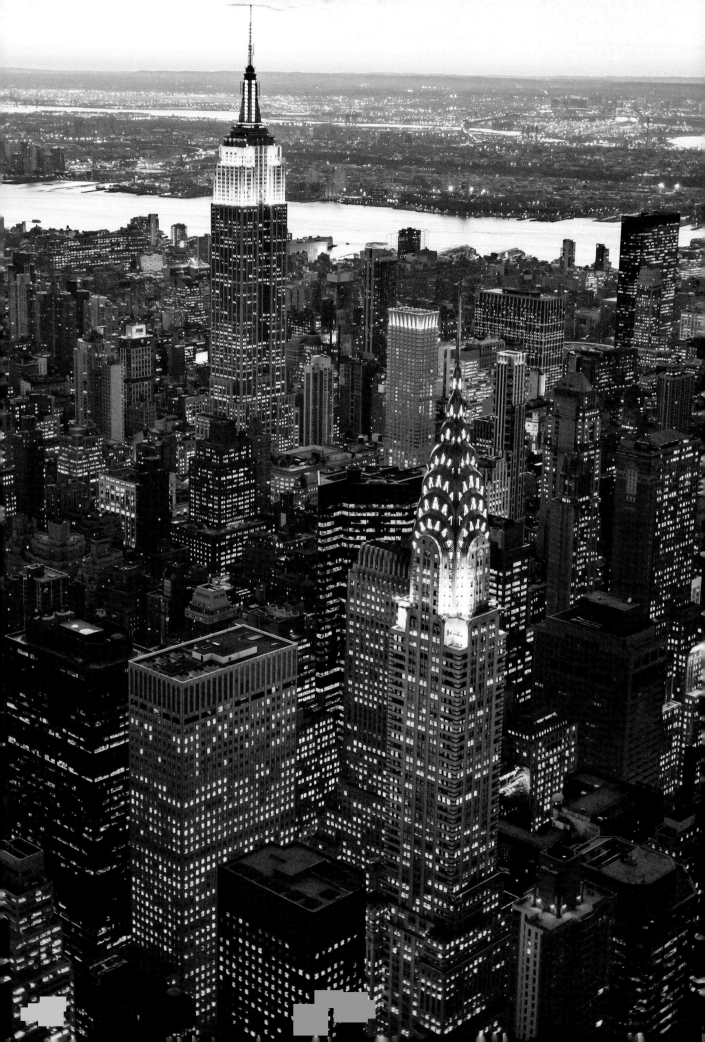

THE PRECURSORS
EARLY TOWERS

The drive for height long predates the skyscraper. The growth of Islam in the Middle Ages would create a demand for minarets, towers from which the faithful could be called to prayer. The Great Mosque of Samarra, in what is now Iraq, was completed in 851. To reach the 171-foot top of its blunt, tapering minaret, visitors ascend a great spiraling ramp along its exterior. The tallest minaret in India is the 12th-century Qutub Minar in Delhi, a 238-foot shaft of fluted red sandstone.

For its own reasons, Christian Europe wanted towers too. In the hills of Tuscany are the medieval towers of San Gimignano. There were 72 at one time, of which 14 survive. They are artifacts of competition among powerful families on opposing sides in the protracted feud between Guelphs and Ghibellines, factions whose warfare convulsed northern Italy in the 13th and 14th centuries. To keep tabs on their rivals, each family built lookout posts as high as 165 feet. Early in the 14th century city authorities put an end to the vertical space race by building a tower of 177 feet and banning new ones from going higher. In response, some families simply erected matching dual towers within the new limits—odd presentiments of the Twin Towers that rose and fell centuries later in Manhattan.

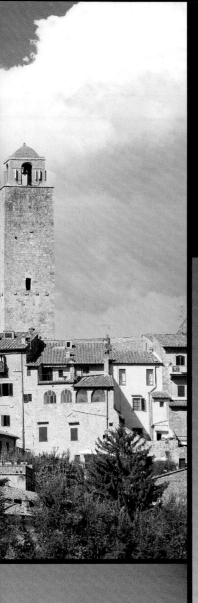

TOWERS OF POWER Clockwise from left: the stone lookout posts of San Gimignano give the town the skyline of a medieval Manhattan; the minaret of the Qutub Minar in Delhi is decorated with carved inscriptions from the Koran; the Great Mosque of Samarra had for a time the tallest minaret in the world.

SAVING THE LEANING TOWER

Even before it was completed, the Leaning Tower of Pisa lived up to its name. It was begun in 1173 as the crowning addition to a new cathedral and baptistry built by the city to mark its emergence as a maritime and military power. By the time it was finished almost two centuries later, it stood 183 feet tall but was already listing 1.6 degrees from center. (Pisa was declining too, but that's another story.) By the late 20th century the tilt had worsened to 5.5 degrees, meaning its top extended 15 feet past its base. That unlikely diagonal made it both one of the most famous buildings in the world and an accident waiting, for centuries, to happen.

There's no mystery as to why it was leaning. It was built on soft, sandy soil, allowing it to sink slightly into the unstable substratum on its southern side. In later centuries misguided human interventions would worsen the problem. In 1838 a walkway was excavated around the tower that caused it to fill with water at its base and shift further. In 1934 it nearly fell thanks to a scheme supported by the dictator Benito Mussolini that involved drilling 361 holes around the base and filling them with 90 tons of cement.

The first of many commissions to investigate the problem convened even before the tower was completed. But in 1989, when an 11th-century tower in the Italian town of Pavia abruptly collapsed, killing four people, the urgency of the problem at Pisa became undeniable. The following year the Italian government convened yet another commission—the 17th—which came up with an ingenious solution. Under the direction of Prof. John Burland, a British expert in soil mechanics, the tower was temporarily stabilized with plastic-coated steel cables wrapped around its second loggia and anchored to the ground. Then a temporary concrete ring was poured around the base to support hundreds of tons of lead weights that were placed on the tower's north side. Those measures succeeded in pulling it back slightly.

Then came the real work. Corkscrew drills were used to install long tubes, eventually numbering 41, along diagonal paths beneath the tower's north side. Via those tubes soil was extracted from that area, allowing the tower to gently subside as the earth beneath it, eventually more than 60 tons, was removed. The tower moved 0.5 degrees, 16 inches back toward center, to the position it occupied before the disastrous walkway excavation of 1838. The rescuers declared that they had stabilized it for the next three centuries—300 more years as a beloved architectural oddity.

▶
The lines at right indicate the tower's deviation from the vertical in various years, measured in arc degrees.

Cables secured to the ground held the tower fast during the rescue operation.
▼

Drilling rigs drove corkscrew drills into the ground to extract soil from beneath the north side of the tower, allowing it to settle back in that direction. ▶

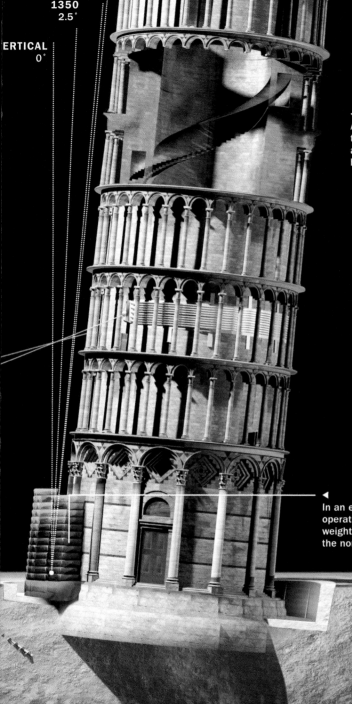

1350
2.5°

ERTICAL
0°

◄

A cutaway view shows
the interior of the tower,
a hollow cylinder that
holds a spiral staircase.

◄

In an early stage of the
operation, 600 tons of lead
weights were placed against
the north side of the tower.

Illustration for TIME by Lon Tweeten

THE UPSIDE Three innovative buildings: left to right, the Willis Tower (formerly the Sears Tower) and the John Hancock Center, both in Chicago, and the World Trade Center in New York.

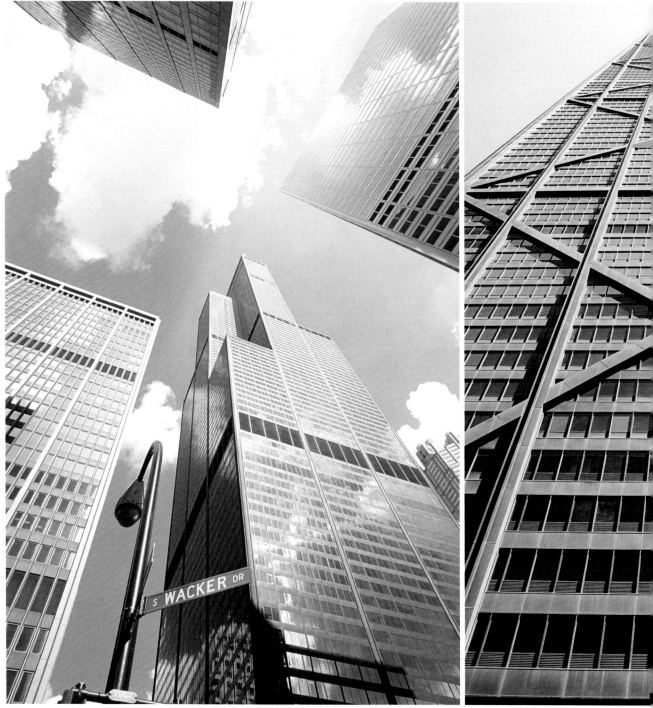

12 | A WORLD OF GLASS AND STEEL

After World War II, advances in materials and engineering techniques made it possible for skyscrapers to go higher and higher, strong enough to withstand immense stresses while having "glass curtain" walls that seemed almost to disappear.

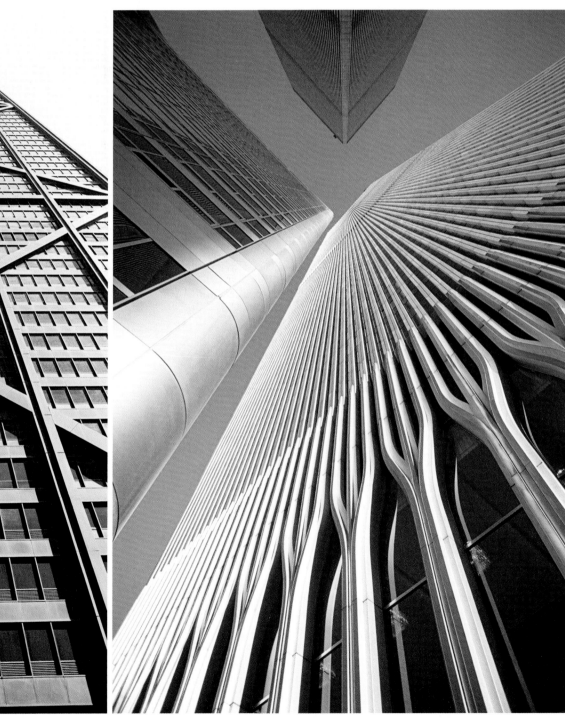

FROM THE FIRST, SKYSCRAPERS meant towers with glass. Even when their exteriors still consisted mostly of masonry, they featured much more glass than had been customary in earlier buildings. Because the walls didn't do the work of supporting the structure's weight—thanks to the steel-frame internal structures—more wall space could be devoted to windows. Inevitably, that led architects and engineers to dream about buildings in which the exterior walls would largely disappear, replaced by transparent "glass curtains." As early as 1922, Ludwig Mies van der Rohe, the German pioneer of architectural modernism, had proposed an all-glass-walled skyscraper project for Berlin.

All through the 1920s and '30s, Mies and other modernists developed their theoretical notion of tall buildings in which glass dominated the exteriors. But they could realize their ideas only in relatively low-rise structures like the Bauhaus Dessau. The famous school of art and design was housed in a building from 1926 by Walter Gropius that had a glass curtain wall. It would not be until after World War II that their ideas would be widely adopted, first in the U.S., and especially in New York City, where the new world of glass towers would truly begin to rise.

The first of them was Lever House, on Park Avenue, completed in 1952 and designed by Gordon Bunshaft very much in the recommended Miesian manner of a glass-and-steel slab on an open plaza. Six years later Mies himself would complete a skyscraper just a few blocks away, the Seagram Building, a master class in how to distill a tall building to its elegant glass-box fundamentals. From those beginnings glass curtain-wall construction came increasingly to dominate skyscraper design, in buildings that were going ever higher and requiring ever more imaginative solutions to the engineering problems the new altitudes created. (For one thing, as buildings climb, "wind load"—the lateral pressure that can cause them to sway noticeably in their upper floors—becomes a serious issue.)

Just as the skyscraper was invented in Chicago, some of the most audacious new structural ideas of the 1960s and '70s came from that city, often through the work of the engineer Fazlur Khan. But among the most innovative towers of the postwar era was one that would stand for almost three decades as the symbol of New York City, until it was brought down in the calamity of 9/11. At 1,368 feet, the World Trade Center had to be innovative. At those heights wind isn't just a straightforward matter of push, but a "wind rose" of eddying vortices that can circulate in multiple directions, creating multiple headaches for its designers. Yet the towers would ultimately be engineered to withstand winds of up to 120 miles per hour.

The design that solved that problem was arrived at through a collaboration between the Trade Center's architect, Minoru Yamasaki, and its chief structural engineer, John Skilling, both based in Seattle. To emphasize the verticality of his paired minimalist towers, Yamasaki designed a palisade of steel piers—"pinstripes," as he called them—to run the full length of each tower's exterior. It was intended at first to be merely a decorative element. Skilling saw those stripes and had an idea. Why not make them structural? Built from new high-strength steel and firmly attached to the floor plates, the piers could be load-bearing columns. They could hold up the building like an exterior skeleton, an adaptation of the "bundled tube" structure that Chicago's Khan had developed. Spaced about 40 inches apart to frame tall vertical windows, the piers would be connected at each floor by horizontal steel spandrels to produce a firmly braced gridwork. A second rank of columns would be placed inside each tower, around the perimeter of the concrete core that contained the elevators and stairway shafts. Those dual lines of support would be strong enough that additional columns

GONE BUT NOT FORGOTTEN
The World Trade Center was largely supported by its own exterior walls. Reflective steel piers running the length of both towers formed a solid external bracing system.

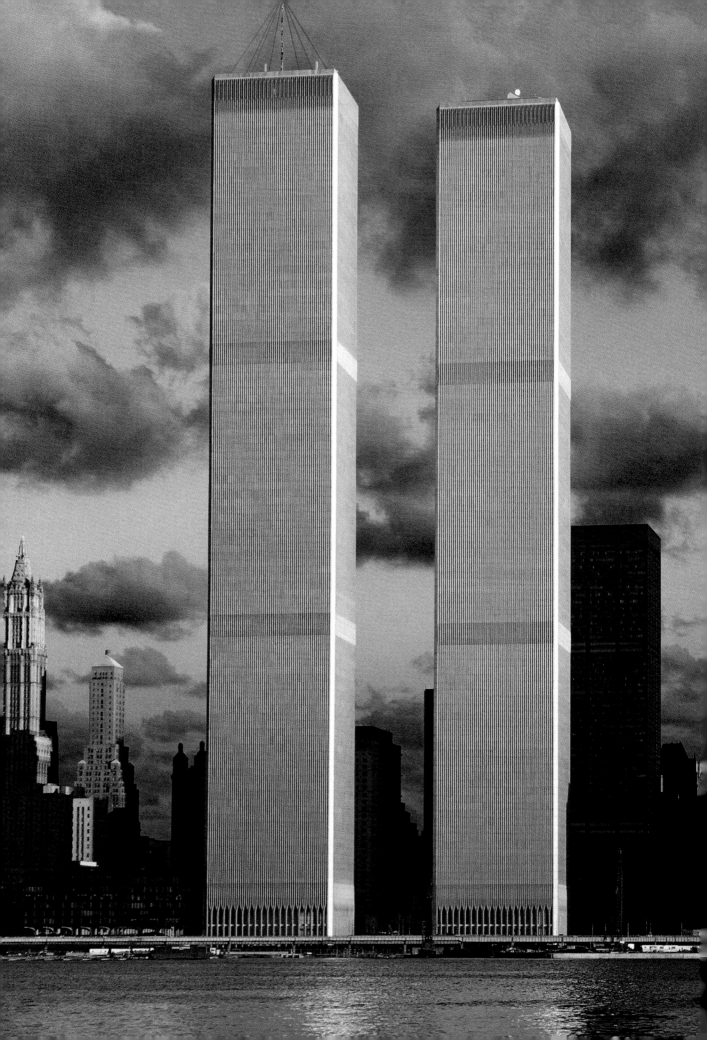

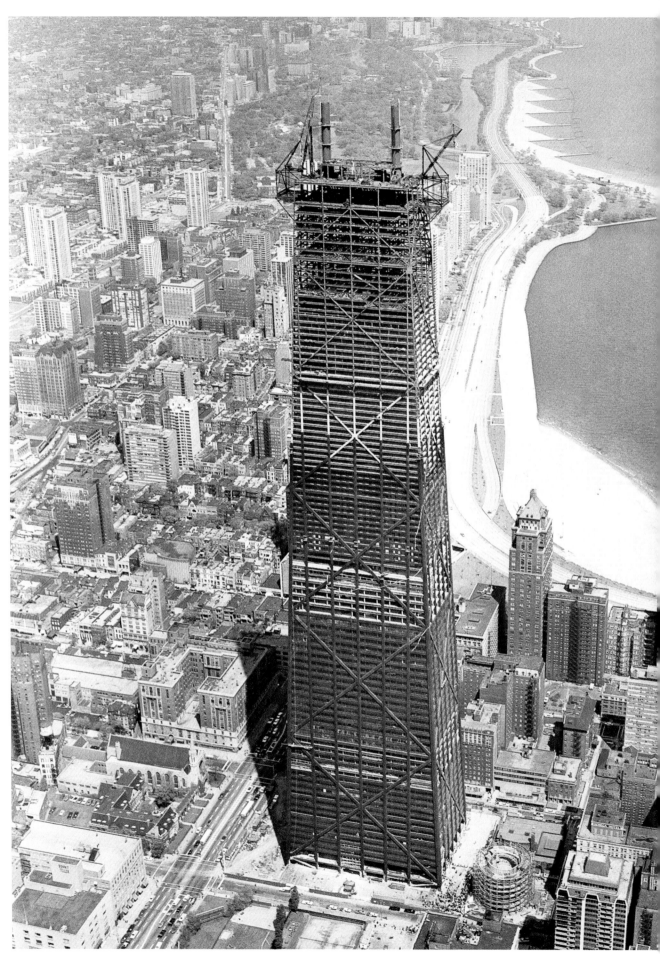

would be unneeded in the area between them, a stretch of as much as 60 feet from the windows to the elevator core, allowing wide expanses of open floor space.

The construction of the World Trade Center was a vast and complicated effort in other ways as well. To further minimize sway, each floor from the seventh to the 107th was equipped with 100 "viscoelastic dampers." Those were something new, a kind of shock absorber for buildings made from sheets of metal attached at the point where floor trusses met the exterior columns, with a flexible layer of epoxy and rubbery glue sandwiched between them to cushion movement. Because the towers were located on the far west side of Manhattan, very close to the Hudson River, they also had to be constructed within a thick-walled, 11-acre underground basin called the bathtub, excavated to a depth of 70 feet and strong enough to prevent the waters of the river from flooding in. Incredibly, digging out the bathtub also meant exposing—and then supporting—the twin tunnels of the

Hudson Tubes, an underground railway that was opened in 1909 to connect Manhattan with New Jersey beneath the Hudson River. The tunnels had to remain in service during the Trade Center's construction process, despite being suspended in midair once the bathtub was opened out. The huge amount of soil and rock removed to make way for that foundation was dumped as landfill into the Hudson, producing a sufficient quantity of new acreage to support Battery Park City, a sizable high-rise neighborhood.

For a time after the Twin Towers came down on September 11, 2001, there was speculation that the urge to build high would go with them. Nothing of the sort happened. Over the next decade, a new generation of even more ambitious skyscrapers would appear in cities all around the world. They became so common that architects and engineers coined a new word to describe them—the supertalls.

THE ENGINEER
FAZLUR KHAN

One of the most creative engineers in American history, Fazlur Khan was born in 1929 in Dhaka, then part of India, now the capital of Bangladesh. By 1960 he was working at one of the biggest American architectural firms, Chicago-based Skidmore, Owings & Merrill. In collaboration there with the architect Bruce Graham, Khan worked on two of Chicago's most famous skyscrapers, each with a highly innovative structure.

For the 100-story John Hancock Center, 1,127 feet tall, he devised a network of columns and diagonal braces that form powerful X shapes on the building's exterior. He called it the "trussed tube" system. Instead of relying on the internal steel framework that skyscrapers had used since the late 19th century, the Hancock is effectively a hollow tube supported by its external structure. The diagonal trusses distribute to the vertical columns both the weight of the tower and the wind loads pressing against it.

For the 1,451-foot Sears Tower (now called the Willis Tower), Khan hit on an idea that would be widely adopted for other skyscrapers in the years that followed. He conceived the building as nine adjoining "bundled tubes," each 75 feet square, like long boxes of differing heights standing on end and connected to one another to form a stable collective. He liked to describe it as "a group of pencils bundled together by a rubber band."

101

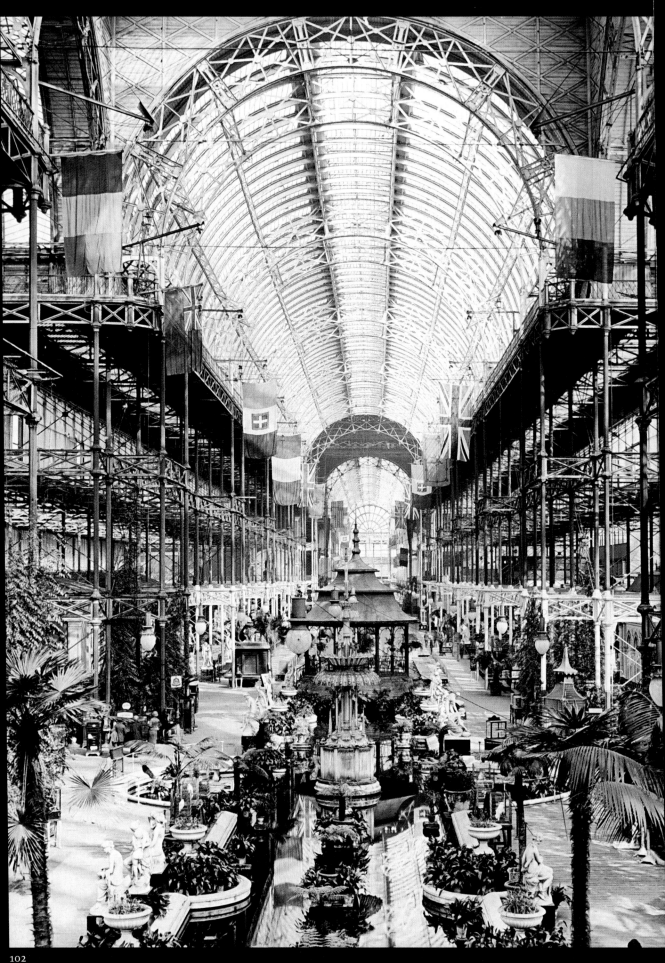

THE CRYSTAL PALACE

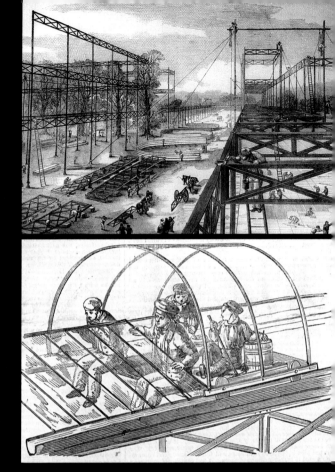

Even before they discovered the usefulness of the steel framework for tall buildings, 19th-century architects and engineers had arrived at iron-trusswork structures holding panels of glass. For centuries metal was hand-forged, making it too expensive for large-scale use in construction. But with the Industrial Revolution came the mass production of cast iron, and later steel. By the mid-19th century, iron and glass were being used for industrial buildings and railway stations.

Those set the stage for the celebrated Crystal Palace by Joseph Paxton, an English designer with experience in the production of iron-and-glass greenhouses. For London's Great Exhibition of 1851 he would produce a vast display hall built almost entirely of the newly paired materials. The largest building ever constructed up to that time, it was also important for its early use of standardized, prefabricated parts.

After the exhibition closed, the Crystal Palace was moved to another part of London, where it was accidentally destroyed by fire in 1936. But by that time its influence had spread widely. By 1876 iron and glass were used for a Paris department store, the Bon Marché. One year later the Galleria Vittorio Emanuele was completed in Milan, a giant iron-and-glass arcade over an entire street of shops and cafés. The Paris Exhibition of 1889—the one that spawned the Eiffel Tower—featured the same materials in a Machine Hall, since demolished, that boasted ceiling arches of an unprecedented width of about 380 feet.

By offering the example of a nearly transparent structure, those buildings helped inspire the glass-and-steel skyscrapers of the next century.

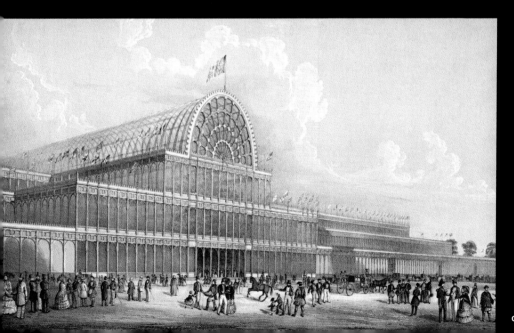

WINDOWS ON THE WORLD Far left, the interior of the Crystal Palace during the Great Exhibition near left, the exterior in a contemporary lithograph; top, an engraving shows the walls being erected above, a rolling car helps workers position panes of glass during construction while their assistants mix putty

13 | THE SUPERTALLS

The thing about skyscrapers is, when it comes to altitude, they just won't quit. Even as more people began to question the social and environmental costs of very tall buildings, their glam factor was enough to keep them reaching for the sky.

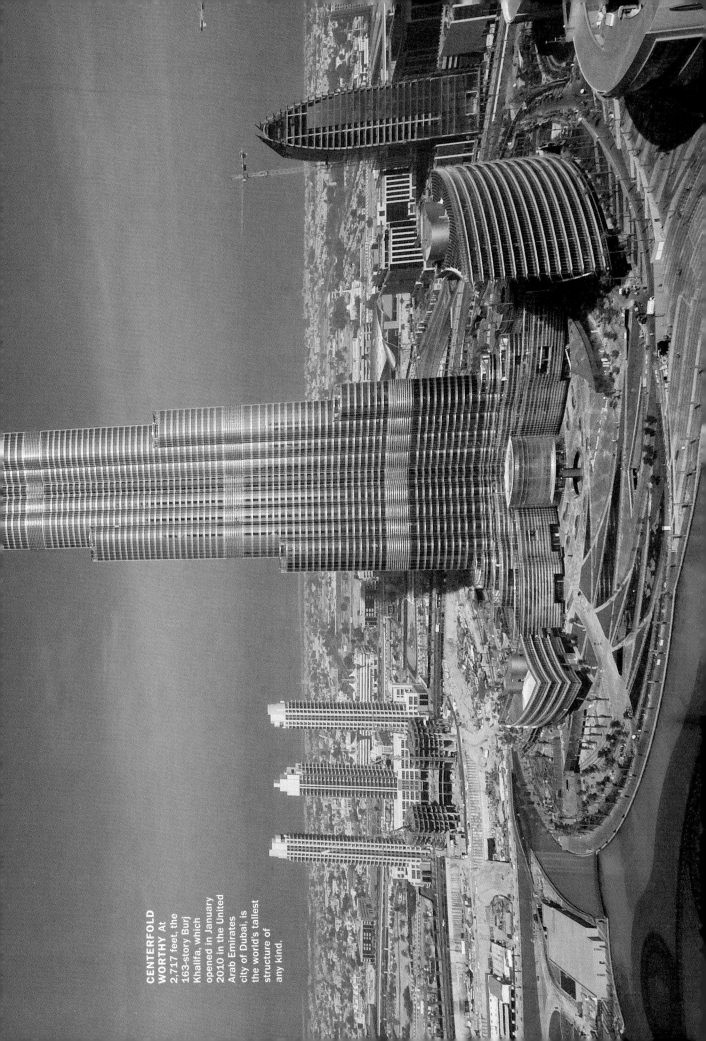

CENTERFOLD WORTHY At 2,717 feet, the 163-story Burj Khalifa, which opened in January 2010 in the United Arab Emirates city of Dubai, is the world's tallest structure of any kind.

STABILIZER
This immense internal pendulum, hung from the 92nd floor of Taipei 101, can sway to counteract the motion of the tower in high winds or earthquakes.

WITH THE COMPLETION OF THE TWIN Towers in 1973, the world took a deep breath. Though they were a remarkable feat of engineering, and could be starkly beautiful from a distance, by their sheer size they epitomized the problems that very tall buildings could create. They weren't just skyscrapers; they were neighborhood busters. They failed to integrate themselves and the vast plaza around them into the surrounding streets. Inevitably, they lent urgency to an emerging debate about the impact of such behemoths on the environment and the urban fabric.

New thinking that grew out of that debate would be reflected in the design of many of the skyscrapers constructed in the 1990s and throughout the first years of the 21st century, a period when, once again, towers continued to reach ever more daunting altitudes. Though for decades it was in the U.S., particularly New York and Chicago, where the most stratospheric buildings sprouted, by the later years of the 20th century the main action had moved to other parts of the world. Just as the U.S. had done before them, emerging nations—first in Asia, then in the oil-rich states of the Middle East—used skyscrapers to announce their arrival on the world stage.

So in 1998 the title of world's tallest building passed from the Sears Tower in Chicago to the 1,483-foot Petronas Towers in Kuala Lumpur, Malaysia. Six years later the tallest was the 1,667-foot Taipei 101 in Taiwan's capital. Then in 2010 the Burj Khalifa in Dubai made a quantum leap to 2,717 feet, roughly twice the height of the World Trade Center. During those same years immense, even if not record-setting, skyscrapers were also completed or under way in Hong Kong, Nanjing, Shanghai, Mecca, Moscow, and London.

Meanwhile, the U.S. had not stepped out of the tall-building business either. The Trump International Hotel & Tower in Chicago would top off at 1,389 feet, the Bank of America Tower in New York at 1,200. And at its completion in 2014, One World Trade Center, overlooking the site where the Twin Towers once stood, will be 1,776 feet. But clearly, the ultrahigh skyscraper—or the supertall, as it has come to be called—had become a worldwide franchise.

Like the towers of earlier decades, the new supertalls required advances in design and materials, such as the huge internal pendulum that prevents Taipei 101 from swaying excessively in high winds and earthquakes. Increasingly, they also relied not on steel framing as their chief structural support but, as the Burj Khalifa does, on "superhard" concrete cores. But some of the most important innovations in skyscraper design involved challenges that were environmental, not structural, dealing with questions of how to make a building energy-efficient or minimize its impact on its surroundings.

The first skyscraper to thoroughly address those issues was the Commerzbank Tower in Frankfurt, completed in 1997 and designed by the British firm of the high-tech master Norman Foster. Though at 850 feet it wouldn't qualify as a supertall, it loomed large in subsequent thinking about skyscraper design. And even at that height it was the tallest building in the European Union until the Shard opened in London in 2012.

A triangular structure surrounding a large central atrium, the Commerzbank is famous for its pioneering, and still unusual, use of interior "sky gardens." At any level offices occupy just two sides of the triangle, leaving the third free to hold a four-story garden that opens onto the atrium. There are nine in all, spiraling upward around the central court. In addition to giving the bank's employees something to look at, the gardens encourage natural air circulation. By admitting more sunlight into the interior, the atrium also reduces the need for electric lighting. The Commerzbank even has operable windows, so that on comfortable days workers can substitute fresh breezes for air conditioning.

Foster's firm would become identified with environmentally friendly tall buildings all around the world. At his Hearst Tower in New York City, completed in 2006, where 90 percent of the structural steel contains recycled material, the cooling system uses rainwater collected on the roof and stored in the basement. But as the 21st century began, Foster would not be alone in finding ways to make skyscrapers go green. The Condé Nast Building in New York, opened in 1999 and designed by the firm Fox & Fowle, has solar panels incorporated in the spandrels on the south and east sides of its upper floors. Though they generate just a small amount of electricity, they represented an early step toward the goal of skyscrapers becoming energy-self-sufficient.

By the time the Shard emerged from the offices of the architect Renzo Piano, it wasn't surprising that a tall building would feature mechanized roller blinds in its all-glass façade to provide shade, reducing the need for air conditioning, and have natural ventilation sources for interior winter gardens. And though it doesn't use solar panels, the tower has its own CHP (combined heat and power) plant that uses natural gas to generate electricity. It then captures the heat created as a byproduct of that process and uses it to provide the building with hot water. By now, architects and engineers everywhere are embracing the idea that it isn't enough to build bigger. They have to build better.

OLD STYLE, UPDATED Taipei 101, below left, represents an attempt at skyscraper design that reflects Asian architectural traditions, in this case the Chinese pagoda. Below right, a cutaway model of the tower's upper floors shows the location of the stabilizing pendulum.

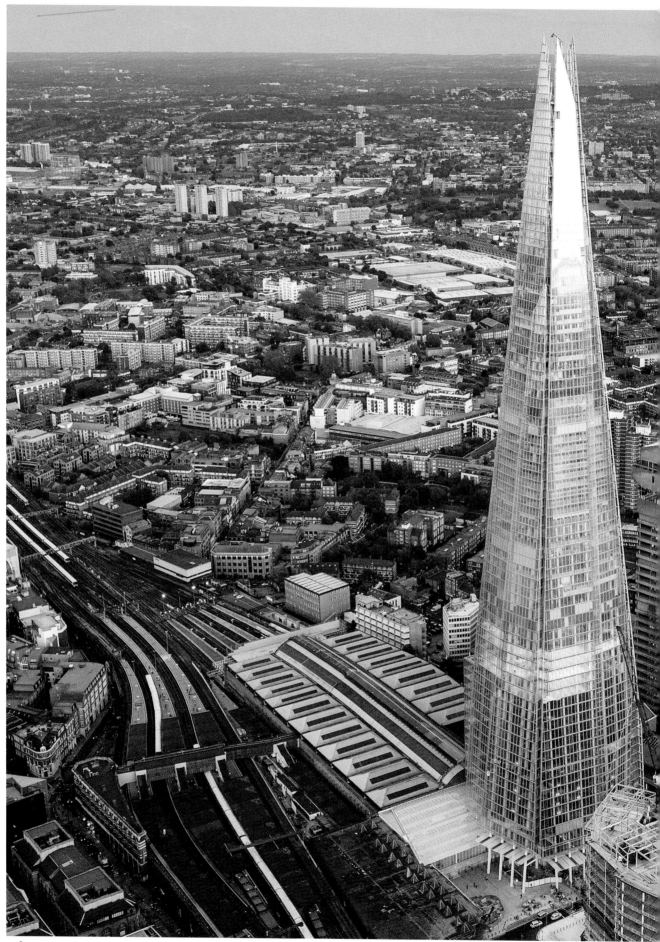

14 | OUTSIDE THE BOX

Skyscrapers weren't the only sensational structures in the decades after World War II. Closer to the ground, architects, engineers, and even artists were going down very new roads to build a world of things in strange and wonderful configurations.

ALL WRAPPED UP
The former Olympic stadium in Beijing is known as the Bird's Nest, and it's easy to see why.

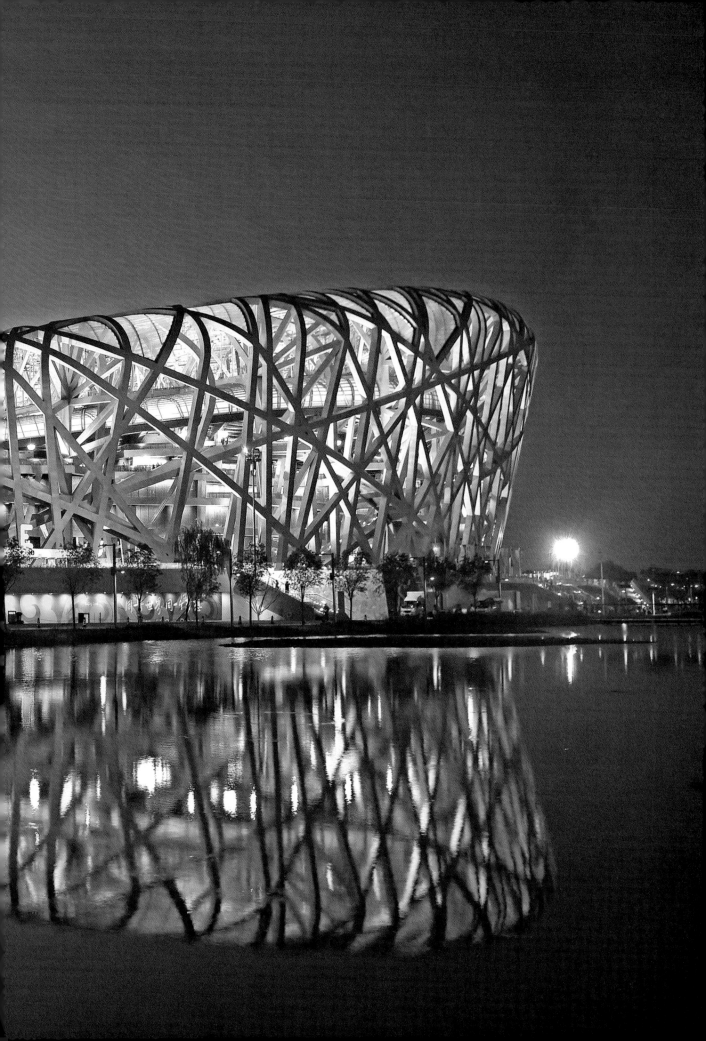

"BIRD'S NEST" STADIUM

BEIJING, CHINA / 2008

WHEN CHINA WAS PREPARING FOR the 2008 Olympic Games, Chinese authorities wanted the principal venue to be something to remember. They certainly got what they were after. No ordinary arena, the "Bird's Nest," as everyone calls the National Stadium, is actually two structures: a red concrete bowl that holds the spectator seating, and a spectacular steel latticework that surrounds and supports it—and thoroughly delights the eye.

To get a better grasp of Chinese culture, the Swiss architects Jacques Herzog and Pierre de Meuron consulted on the project with the noted Chinese artist Ai Weiwei. The fabric of steel diagonals was originally conceived to disguise large beams required to support a retractable roof. Though the roof was eventually dropped from the stadium design, the fascinating web of interlacing steel bands remained, helping to give the exterior the "porous" quality, a sense of being open to its surroundings, that the architects were seeking. As Herzog explained: "We're interested in complexity and ornamentation, but of the kind you would find on a Gothic cathedral, where structure and ornamentation are the same."

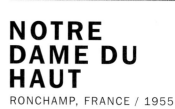

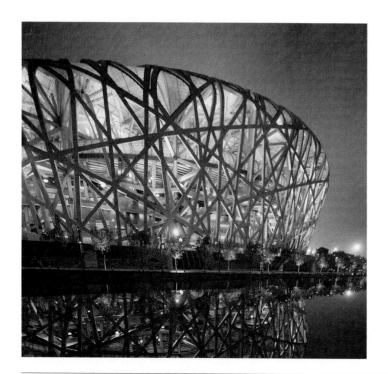

NOTRE DAME DU HAUT

RONCHAMP, FRANCE / 1955

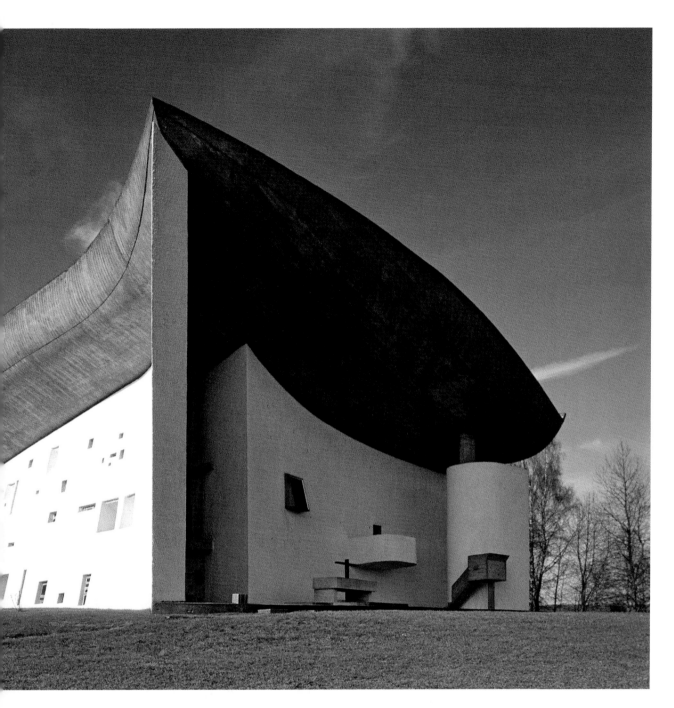

FOR CENTURIES THERE HAD BEEN A
succession of pilgrimage chapels on a
hillside above the village of Ronchamp
in eastern France. When what might
have been the last of them was
destroyed in World War II, it was decided
that yet another should rise in its place.
Under the guidance of a forward-look-
ing priest, Father Marie-Alain
Couturier, the commission to design
the new chapel went to the most
forward-looking of architects: Le
Corbusier, the Swiss-French designer
who was one of the founders of
modernism. What he decided to build

there was not a rectangular box of the
kind identified with the 20th-century
architecture he had done so much to
formulate, but a billowing and almost
dreamlike essay in flowing form.

Who knew that humble concrete
could have such lyrical power? Le
Corbusier was fascinated by concrete,
and he played a crucial role in legiti-
mizing its use in ambitious modern
architecture. At the chapel at Ron-
champ, he even proved that heavy
reinforced concrete—in places the walls
are 10 feet thick at the base—could
transmit a weightless sense of spirit.

He accomplished that in part by
leaving a four-inch space between the
roof and the walls, a slot running
around the perimeter of the chapel that
admits a glowing strip of sunlight.
That gap meant the roof, which was
inspired partly by a seashell the
architect found on a beach on Long
Island, could not actually rest upon
the walls. Instead, concrete columns
embedded in the walls emerge at
intervals to support it. By that means
the roof appears to float, like a
weighty heaven, above the sacred
space it shelters.

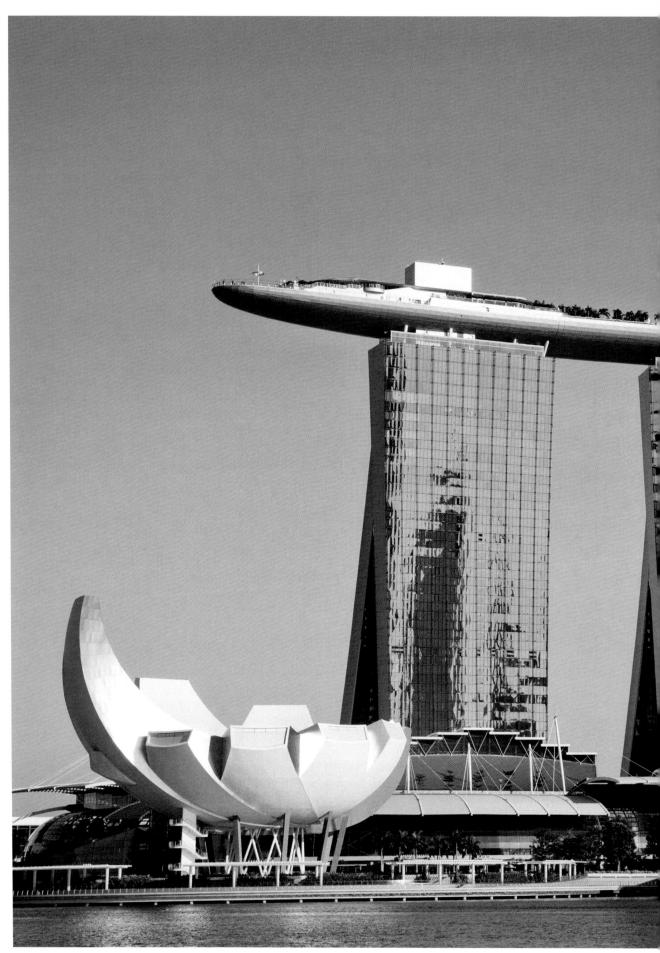

MARINA BAY SANDS

SINGAPORE / 2010

THE 21ST CENTURY HAS BEEN A great time for what could be called the architecture of spectacle: amazing (and sometimes amazingly theatrical) buildings meant to catch the eye. Hotels and casinos—places that promise to be an experience, not just a destination—are especially given to this kind of wow-factor design. One of the most audacious examples is the Marina Bay Sands Integrated Resort, a hotel/casino complex in Singapore that includes restaurants, nightclubs, live-performance theaters, a convention center, a three-acre Skypark riding across a trio of towers, a long, vertiginous swimming pool perched 650 feet above the ground, and a museum shaped something like a lotus blossom—or perhaps an unfolding artichoke.

It's all the work of Moshe Safdie, the Israeli-born Canadian architect who became abruptly famous in his late 20s for Habitat 67, a modular housing complex he designed for the 1967 world's fair in Montreal. Working with the Arup engineering firm, Safdie provided three 55-story towers of glass and reinforced concrete as the centerpieces of what is billed as the most expensive hotel/casino complex in the world. (It cost a reported $5.7 billion to complete, a figure that includes the purchase price of the land it sits on.) The towers flare outward at the base to produce "legs" that frame a continuous atrium running the length of all three. Multistory steel trusses attach the legs at the 23rd floor.

The towers support the Skypark, a 1,115-foot-long platform as big as an aircraft carrier—or the Eiffel Tower tipped on its side—that cantilevers almost 213 feet over the edge of the north tower. In the vast infinity pool, 15,000 square feet and the length of three Olympic pools, the water makes a sharp horizon line against the sky, giving the appearance that it simply drops off the edge of the tower, though in fact it spills into a catchment shelf just below to be recycled.

Placing the park and pool on top of the resort not only provided the building with an extreme architectural flourish, it removed those features from the ground-level footprint, leaving more room for things like the convention center and museum. In a city with real estate as expensive as Singapore's, sometimes it's more economical to put a park in midair.

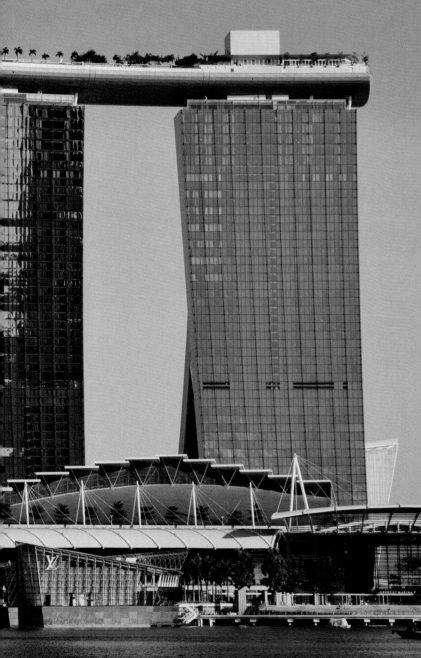

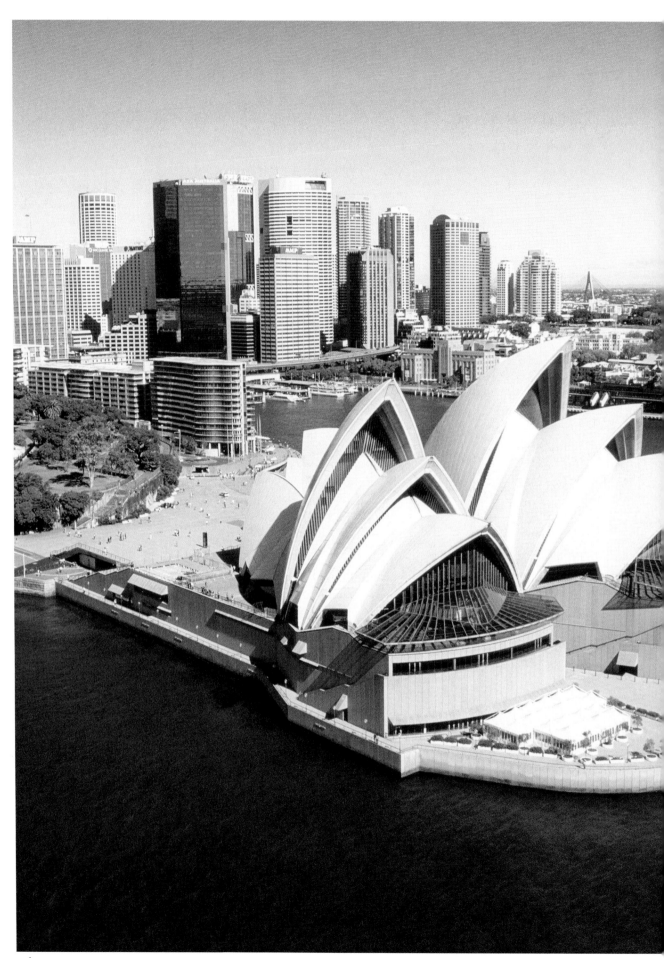

SYDNEY OPERA HOUSE
SYDNEY, AUSTRALIA / 1959 TO 1973

THERE IS NO GREATER CAUTIONARY TALE about the difficulties of building a radical new vision than the Sydney Opera House. Today it's a much-admired building, a symbol not just of Sydney but of Australia. Its construction, however, was an ordeal. In 1957, the 39-year-old Jørn Utzon was an architect little known outside his native Denmark. But that year he won the international competition to design an opera house on Bennelong Point, a highly visible promontory in Sydney Harbor. His proposal called for a series of curving concrete shells, like billowing sails, to hold the concert halls. These would rest on a mammoth platform containing the dressing rooms, rehearsal areas, and other subsidiary spaces. The scheme so impressed one of the judges, the celebrated Finnish-American architect Eero Saarinen, that he plucked it from a pile of entries that had already been eliminated and declared it the winner.

Then the trouble started. Utzon had not offered much in the way of specifics as to the precise form of the shells or how they should be built. They turned out to be devilishly difficult to engineer and threatened to be much too heavy for the platform they would rest on. With the help of the British structural engineer Ove Arup, Utzon produced a revised design that envisioned the 14 shells as segments of a single sphere. Put them together and they would form a ball 300 feet in diameter. The shells would be supported by concrete ribs and covered with white ceramic tiles.

This design provided the basis for a buildable opera house. But Utzon would not be the one to finish it. Amid controversies over the engineering difficulties and cost overruns, a new and unsympathetic premier of New South Wales put the project under the control of the Ministry of Public Works. At that, Utzon resigned and left Sydney. An Australian firm saw the opera house through to completion, though largely to Utzon's design. When it was finished at last in 1973, Utzon did not attend the opening. At his death at age 90 in 2008, he had still never seen the building that by that time had made him widely—and rightly—famous.

THE ENGINEER
OVE ARUP

The problematic construction of the Sydney Opera House was a painful experience for its architect, Jørn Utzon. But it became a personal triumph for Ove Arup, who went on to become one of the few 20th-century engineers well known in their own right. With his associate Peter Rice, Arup was credited with solving the complex technical challenges of the opera house's roof, which required innovative use of the precast concrete that was his specialty.

Born in 1895 in Britain to a Danish father and Norwegian mother, he considered becoming an architect, but decided that his real gifts were in the realm of mathematics, not aesthetics, though his elegant and simple solutions to engineering problems had a beauty all their own. After his death in 1988 the firm he founded, now called Arup, continued to be involved in some of the world's most celebrated projects, including the Millennium Bridge and the Shard tower in London, the CCTV Headquarters and the "Bird's Nest" Olympic stadium in Beijing, and the Chunnel— the Channel Tunnel Rail Link.

SPIRAL JETTY

GREAT SALT LAKE, UTAH /
1970

THOUGH IT SPRANG FROM THE imagination of just one man, not an entire lost culture, you could still think of the Spiral Jetty as the Stonehenge of the 20th century. A mysterious assemblage of rocks, it seems almost like a natural formation—spirals, after all, are found frequently in nature—but by its simple, compelling geometry it's unmistakably the product of human design.

This circling path was created by the artist Robert Smithson, a pioneer of earthworks, an art form that arose in the late 1960s. At a time of radical distrust of capitalism, earthworks promised a way to rescue art from the clutches of the market. (Try stuffing a huge coil of boulders into a gallery.) But artists like Smithson also had a much larger agenda: to restore to art a sense of the monumental and, more than that, the fundamental, to imbue it with the power of massive geological form and of slow geological time.

Construction was a relatively straightforward task. Over six days in April 1970, Smithson and two assistants used two dump trucks, a front loader, and a tractor to unload big chunks of black basalt and soil, 6,650 tons in all, into shallow water on the north end of the Great Salt Lake. Within two years of its completion, however, the jetty was under water, due to a cycle of heavy rain and floods that began in 1972. A year after that, Smithson was dead, the victim of a helicopter crash near Amarillo, Texas, where he was scoping out the site of his next proposed project. But over time, the jetty would undergo a series of transformations. Drought conditions allowed it to reappear in 2002, only to be submerged again a few years later, to reappear once more and to be submerged yet again. As Smithson might have hoped, the Spiral Jetty has been absorbed into the cycles of nature.

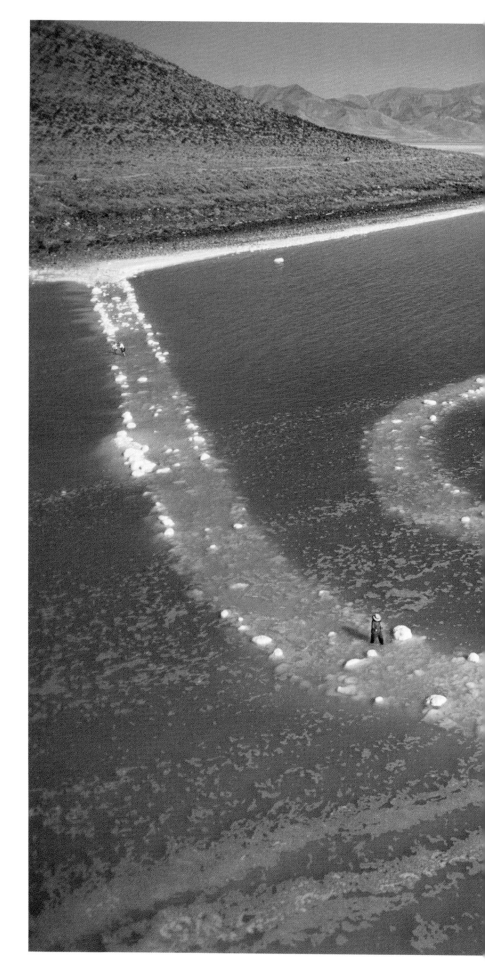

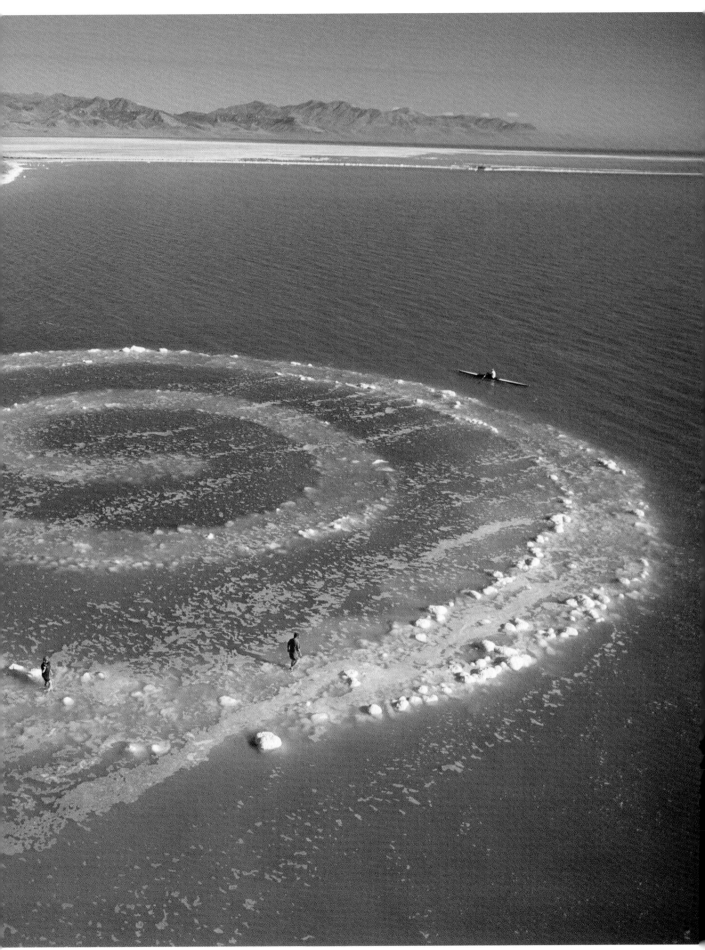

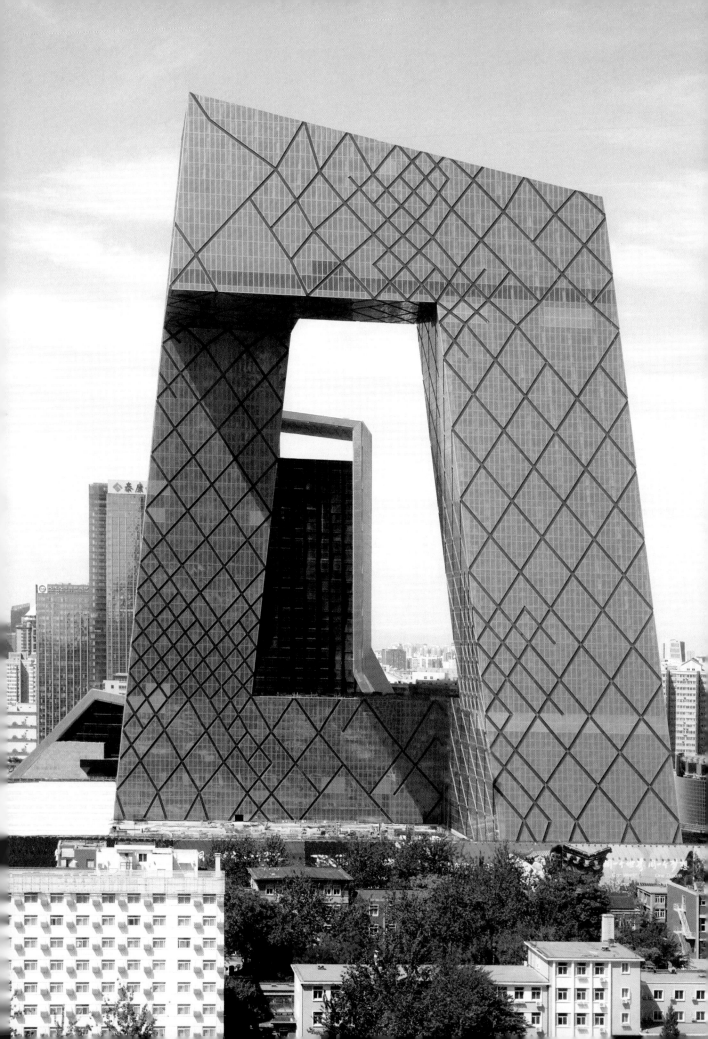

CCTV HEAD-QUARTERS

BEIJING, CHINA / 2012

WE KNOW THAT BUILDINGS CAN CLIMB. We know they can spread out wide. But until the CCTV Headquarters, who knew they could do a somersault? Designed for China Central Television, the nation's official government-controlled network, and set to become fully operational in 2013, it will house offices, broadcast studios, and production facilities in a building shaped as no building has been shaped before. The locals call it the big boxer shorts.

Something this out of the ordinary could have come only from the Office for Metropolitan Architecture (OMA), the Rotterdam-based firm headed by the Dutch architect, theoretician, and polemicist Rem Koolhaas. In his books and public utterances, Koolhaas has been increasingly critical of the standard tall tower, in part for its way of isolating the people who use it on their separate floor plates. Working with the noted engineer and designer Cecil Balmond, Koolhaas and his former OMA partner Ole Scheeren devised a looping irregular structure, 44 stories high. At the top it contorts itself into a glass bridge, bent at a 90-degree angle, that corresponds to a similar formation along the base. The intention of the continuous form is to join all aspects of the CCTV operation into an interconnected loop, and hopefully foster creative and personal connections among the people who work there as well.

What keeps it standing? Like many tall buildings, the 768-foot CCTV Headquarters wears its structure on the outside, in its crisscross steel webwork. Rather than provide a uniform web, the designers chose to concentrate support in areas of greatest stress, resulting in denser transverse intersections of steel in those places. The exterior latticework is effectively a map of the forces that travel throughout the whole structure like nerve paths.

Architects are always hoping to encourage social change through their designs. Will CCTV succeed in its ambition of making the workplace into a real community? If it does, expect to see more buildings go trapezoidal.

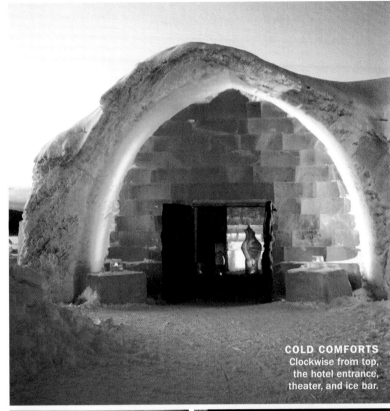

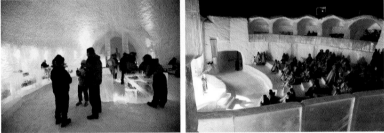

COLD COMFORTS
Clockwise from top, the hotel entrance, theater, and ice bar.

ICE HOTEL

JUKKASJÄRVI, SWEDEN / REBUILT ANNUALLY

LOOKED AT ONE WAY, ICE HOTELS ARE NOT SUCH A NEW IDEA. THEY are, after all, descendants of the igloo, the hemispherical homes built for centuries by the Inuit people of the Arctic regions of the U.S., Canada, and Greenland. But your average igloo doesn't feature a lobby, a chapel, an ice bar, and rooms for more than 100 guests where even the beds are cut from blocks of ice.

For the earliest and largest example, which first emerged in 1990 in Jukkasjärvi, 125 miles north of the Arctic Circle, some 9,000 tons of ice and 27,000 tons of snow are harvested every spring from the nearby Torne River and stored. Construction usually begins in mid-November, when snow is sprayed on arched steel frames and allowed to freeze. The frames are then removed, leaving walls of freestanding ice and snow. Where blocks of ice are used, instead of mortar they are bound together by "snice," an amalgam of snow and ice. Since the hotel is remade every year—it stands only from December to April—the design and architecture change with each new iteration. But one thing remains the same. All the walls, fixtures, and fittings—even the cocktail glasses—are made of ice and packed snow. This is a place where you can not only get a drink on the rocks, you can get it *in* the rocks.

GUGGENHEIM BILBAO

BILBAO, SPAIN / 1997

NOT LONG AFTER IT WAS COMPLETED, Frank Gehry's bowing, bending, and sometimes even hurtling Guggenheim Museum in Bilbao, Spain, was certified as "the most important building of our time" by no less an authority than the late Philip Johnson, then the gray eminence of American architects. More than a decade later that verdict still sounds right. As buildings go, it may also be the most purely pleasurable. With its improbable towers tilting against one another and its titanium sheathing in full refulgent glow, it brings to mind the kind of happy question the world asked itself after the first moon landing. If this is possible, what isn't?

However playful they appear, those dancing silhouettes were a lot of work to build. Few of the Guggenheim's walls are perfectly vertical; most of them billow and wave. Finding a workable support structure was like designing a corset for a belly dancer. It was also a challenge not unlike the one that faced Gustave Eiffel when he considered how to hold up the rippling copper exterior of the Statue of Liberty. Gehry, too, regarded his building as in some ways a work of sculpture. But he solved its structural questions through the use of advanced computer software, a tool most sculptors don't require.

By the late 1990s a revolution had swept the fields of architecture and engineering. "Computer-aided design" (CAD) made possible confident performance calculations about support systems and related construction issues for buildings, bridges, and other structures, even ones with unusual forms. For the Guggenheim, Gehry adapted a sophisticated software program called CATIA (Computer-Aided Three-Dimensional Interactive Application) that was originally developed for the design of French military jets and had been used to engineer the Boeing 777. This made perfect sense. The parabolas of the Guggenheim meant that in places it resembled an aircraft

body more than a conventional building. The computer renderings also made it possible to give precise guidance to fabricators and other contractors who provided the unconventionally shaped components of Gehry's building.

It's not so surprising, then, that the museum was completed on schedule and on budget, despite its use of relatively costly titanium for its exterior panels. But Gehry was able to take advantage of a temporary drop in the price of titanium, a strategic metal used in the production of military aircraft. That was due largely to the collapse of the Soviet Union in 1991 and the subsequent reduction in its military spending. So you might say the Guggenheim Bilbao, or at least its irresistible glow, was another of those "peace dividends" that grew out of the fall of the Berlin Wall.

MILWAUKEE ART MUSEUM

MILWAUKEE, WISCONSIN / 2001

FOR HIS EXUBERANT ADDITION TO THE
Milwaukee Art Museum, the Spanish architect
Santiago Calatrava provided the city with a
suave exercise in forward-looking architectural
romanticism. With its slightly retro aerodynamic
lines, his building manages to refer to Gothic
cathedrals, the sailboats visible on nearby Lake
Michigan, and the wingspread of a bird in
flight—all that plus a nod to the architect Eero
Saarinen, designer of the museum's main
building across the way, who had used a swelling
bird's-wing silhouette half a century earlier for
his TWA terminal at New York's JFK airport.

You enter what's called the Quadracci Pavilion
(named for its principal donors) beneath a
90-foot-high vaulted glass ceiling meant to invoke
a soaring Gothic nave. Though glass is used
extensively, the pavilion, like the Sydney Opera
House, is also a demonstration of the lyrical
potential of concrete. Much of it was constructed
by pouring concrete into custom-built wooden
forms. Though Calatrava is a structural engineer
as well as an architect, many of the elements that
create the distinctive contours of his work are
purely decorative, put in place simply to add
visual drama. That would describe the building's
most celebrated feature, the Burke Brise Soleil.
A 90-ton sunscreen with movable wings made of
72 steel fins, it rests lengthwise along the pavil-
ion's glass-enclosed central hall. Measuring 217
feet from tip to tip, its wingspan is comparable to
that of a Boeing 747. On most days the wings
open at 10 a.m. When fully deployed they give the
sunscreen the appearance of an origami bird.
They close and open again at noon, then close for
the day at 5 p.m., a performance that literally
brings down the house. Sensors can also close the
wings automatically whenever they detect wind
speeds above 23 mph. Though the pavilion sits on
the shore of Lake Michigan, a single-spar, cable
suspension pedestrian bridge, also by Calatrava,
links it to the rest of the city.

Did the museum really need a massive un-
dulating sunshade? Of course not. But function-
ality isn't everything. Sometimes pure delight
is enough. With the brise soleil, a building
that seems to be in motion everywhere literally
flaps its wings.

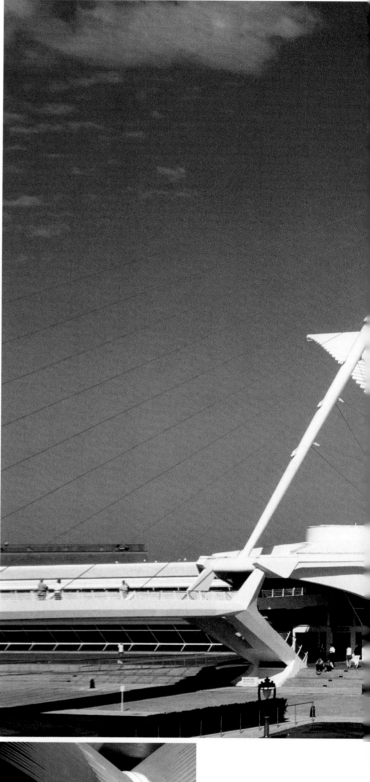

THE ARCHITECT-ENGINEER
SANTIAGO CALATRAVA

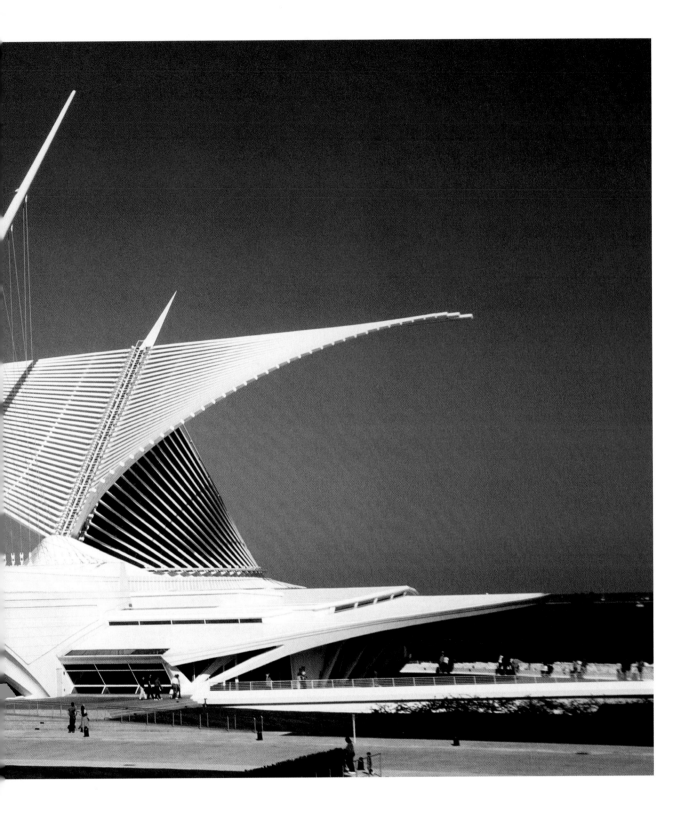

Santiago Calatrava is an architect who is also trained as an engineer. For good measure he's a sculptor as well, and his distinctive bridges and buildings—parabolic sculptural forms that use imaginative feats of engineering to explore the poetics of structure—bear the input of all three disciplines. Born in Valencia, Spain, in 1951, as a child he liked to sketch the pigeons that his parents raised, and bird forms have appeared in a number of his best-known works.

By the early 1980s, Calatrava was getting his first major commissions, for a train station in Zurich and a bridge at the Barcelona Olympics. There followed scores of high-profile assignments for bridges in Europe, the U.S., and Israel; train stations in Lille, France, and Liège, Belgium; the Athens Olympic stadium; an airport in Bilbao; and a multibuilding arts and sciences center in his hometown. His addition to the Milwaukee Art Museum was his first building in the U.S., but coming up is a major transit station at the site of the World Trade Center in New York, an angular palisade of white ribs with an upward thrust. Typically, he says it was inspired by the idea of a child releasing a bird into the air.

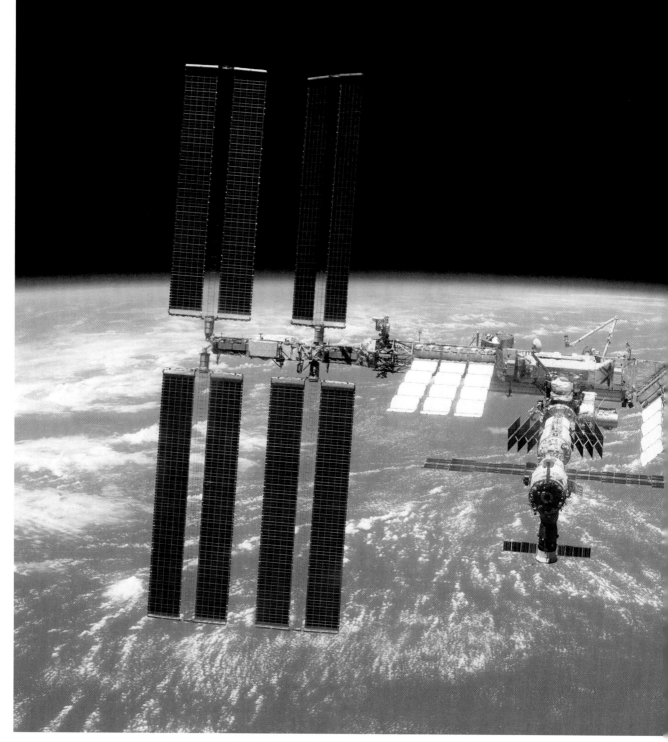

15 | THE INTERNATIONAL SPACE STATION

As humans explore space, they will carry with them the impulse to build. But now they will do it in conditions unlike anything found on Earth, which will produce structures unlike anything seen before. One of them is already circling the globe.

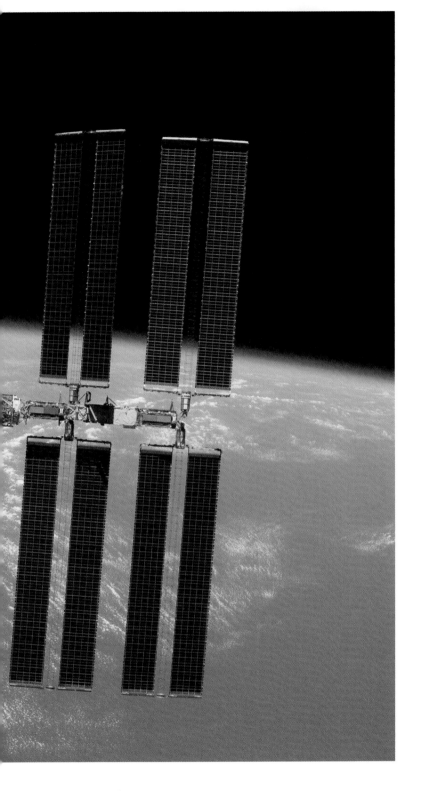

PEOPLE HAVE BUILT IN DESERTS, ON mountaintops, and on water. (Or at least on long piers driven into the seabed to support oil drilling platforms.) But when it comes to constructing things in difficult circumstances, the ultimate problem has been how to assemble a human habitat and workplace in the weightless vacuum of space. That's a challenge that has been met in stages since 1998 with the International Space Station (ISS), an orbital spacecraft more properly thought of as a building in space.

From the early 20th century, orbiting platforms were a dream of both scientists and science-fiction writers. In the 1970s and '80s they began to take shape when the Soviet Union and the United States separately launched manned orbital laboratories—first the Salyut and Skylab vehicles, then the multimodule Soviet Mir—that were designed for long-term missions. But not until the collapse of the Soviet Union in 1991 was it possible to arrange a joint project between the formerly competitive space powers, one that could result in a larger and more sophisticated platform. That would be the ISS, an orbital laboratory where flight crews assigned for months at a time pursue research in fields such as astronomy, space medicine, and meteorology.

A Russian Proton craft carried the first module of the ISS into space in November 1998. Two weeks later the American space shuttle *Endeavour* brought the second. Numerous Russian and American delivery missions would add further components, including modules from Japan and the European Space Agency. In its final configuration the ISS is by far the largest thing ever put into Earth orbit. (At a cost of $150 billion, it's also the most expensive object of any kind ever constructed.) At its center are the 14 main modules, jointly the size of a five-bedroom house, where the astronauts live and work. Attached to that cluster is a 356-foot-long truss, almost exactly the length of a football field, supporting an array of solar panels that can move to track the position of the sun. Traveling at more than five miles per second, the ISS circles the Earth about every 90 minutes at an altitude of roughly 220 miles. Anyone equipped with a household telescope can see it on many nights for themselves—a building that flies, a cabin in the sky.

127

CREDITS